Letters on Cézanne

er frage Degrees

Rainer Maria Rilke Letters on Cézanne

EDITED BY CLARA RILKE

Translated by Joel Agee

Fromm International Publishing Corporation

NEW YORK

Translator's Acknowledgment

The translator thanks Lola Gruenthal for going over the manuscript and making numerous, valuable suggestions.

Translation copyright © 1985 Fromm International Publishing Corporation New York

Originally published as Briefe über Cézanne Copyright © 1952, Insel Verlag, Frankfurt

All rights reserved. No part of this book may be reproduced or utilized in any form or by any means, electronic or mechanical, including photocopying, recording or by any information storage and retrieval system, without permission in writing from the Publisher.

Inquiries should be addressed to Fromm International Publishing Corporation, 560 Lexington Avenue, New York, N.Y. 10022

Designed by Constance Fogler
Printed in the United States of America
First U.S. Edition

Library of Congress Cataloging in Publication Data

Rilke, Rainer, Maria, 1875–1926 Letters on Cézanne.

Translation of Briefe über Cézanne.

1. Rilke, Rainer Maria, 1875–1926—Correspondence.

2. Authors, German—20th century—Correspondence.

3. Rilke, Clara. 4. Rilke, Rainer, 1875–1926—Knowledge—Art.

5. Cézanne, Paul, 1839–1906. I. Rilke, Clara. II. Title.

PT2635.I65Z49313 1985 831'.912 [B] 85–16014 ISBN 0-88064-022-7

ISBN 0-88064-107-X (pbk)

First U.S. Edition, October 1985 Second Edition, August 1986 Somehow I too must find a way of making things; not plastic, written things, but realities that arise from the craft itself. Somehow I too must discover the smallest constituent element, the cell of my art, the tangible immaterial means of expressing everything . . .

To Lou Andreas-Salomé, August 10, 1903

Translator's Foreword to the second edition

The reader will encounter a few lines where Rilke's language hovers so tentatively and elusively around its subject that a second or third reading is needed before the meaning begins to emerge. I have not attempted to clarify these passages; they were written that way. But it would be a mistake to regard them as lapses in an otherwise lucid performance by Rilke. Even the clearest water seems opaque at great depth.

Here and there, I have made small changes in the direction of greater fidelity to the original.

> Joel Agee Brooklyn, New York

FOREWORD

Rilke was once asked to name the formative influences on his poetry. He replied, in a letter from Muzot, that since 1906 Paul Cézanne had been his supreme example, and that "after the master's death, I followed his traces everywhere." This is not an isolated remark; it could be complemented by numerous other statements which powerfully attest to the importance the painter held for the poet. In one letter, he speaks of an insight which struck him like a flaming arrow while he stood gazing at Cézanne's pictures: that here was one who remained in the innermost center of his work for forty years, and that this explained something beyond the astonishing freshness and purity of his paintings. For in a "conflagration of clarity," Rilke had realized that without such perseverance, the artist would always remain at the periphery of art and be

capable only of accidental successes; an insight which touched upon Rilke's painfully divided allegiance to life and to the great work. That is why the example of this man who had learned to endure like the kernel in the flesh of the fruit assumed virtually mythic proportions for him, so that in the end Cézanne looms like a "Homeric patriarch" whose warnings against the darkening of the earth had the weight of prophesy. "For one thinks of him as of a prophet," Rilke wrote in 1916, "but they have all left earlier, those old men who would have had the power to weep before the nations of our day." The same sense of something extraordinary, even enormous, is expressed in a remark Rilke made to Count Harry Kessler in front of a picture of the Montagne Sainte-Victoire: "Not since Moses has anyone seen a mountain so greatly." For the poet, this painter and his work formed a unity that exceeded artistic and aesthetic criteria: "Only a saint could be as united with his God as Cézanne was with his work." Thus Cézanne and his art assume a central position among the "tutelary spirits" that cast a guiding light on Rilke's path as a poet.

The series of contemporary painters who merit mention in this connection reaches up to

Picasso and Chagall. Many of these artists were relatively close acquaintances and friends of Rilke's: Emil Orlik, for instance, whom he had known since his early youth in Prague, and Heinrich Vogeler and Paul Klee. His trips to Russia—for which the studio sketch "Vladimir the Cloud Painter" was a kind of preludebrought him in contact with numerous Russian painters, among them the famous realist Ryepin and the impressionist Levitan (more congenial to the poet's lyrical sensibility), and Leonid Pasternak. But the "God-seeker" Rilke, who perceived the dual orientation of Russian art toward man and God as its very essence, was more drawn to the religious painting of a Kramskoy, an Ivanov -and above all to those "milestones of God," the icons. There is a description by Clara Rilke that seems indicative: a Ukrainian peasant was so touched by the inwardness of Rilke's appearance that he gave him an icon which until then had been the protector of his cottage. Rilke's attraction to these works was not primarily artistic; there was a presence in them of the artist's nearness to God, and it was this that moved him.

At a later time, the poet said that he did not learn how to look at pictures until he had met and talked with artists; that previously he had

searched many a painting for a narrative or lyrical content instead of regarding it as an artwork: "proof of my immature eyes." His stay in Worpswede, the proximity and friendship of Heinrich Vogeler, brought him together with two artists who became his teachers in the art of seeing: Paula Becker and Clara Westhoff. "How much I am learning through the gaze of these two girls, especially the blond painter, who has such brown and watchful eyes!" While Paula introduced him to the nature of color, it was Clara's work that gave him access to the language of sculpture, leading him directly into the world of her great teacher Rodin, whose creations cast their bronze shadows on Rilke's poetic productions, sometimes with nearly overwhelming effect.

His friendships with artists left visible traces in numerous poems, but there were deeper effects. The artist's craft became an almost envied model for the poet in his constant struggle for "the smallest units of language." Craft, handicraft, the process of forming and shaping—Orlik's woodcuts, for instance, with their rejection of color—had caught his interest long ago. Now, under the influence of Rodin, his attention sharpened: "Somehow I too must discover the smallest

constituent element, the cell of my art, the tangible immaterial means of expressing everything" (to Lou Andreas-Salomé, 1903). It was hardly surprising, therefore, that such efforts at clarification would occasionally prompt him to attempt a descriptive treatment of the subject. Most of these ideas never went beyond the wishing and planning stages; the essays on Kramskoy and Ivanov remained as unwritten as those on the French painter Carrière, or the Spaniard Zuloaga, whose fashionable art soon paled, for Rilke, in the light of El Greco. Only his friendship with the painters in Worpswede and his admiration for Rodin took shape as finished pieces of writing. But none of Rilke's many and various contacts with contemporary art and artists—with the possible exception of Rodin, at least in certain respects-had as decisive an impact as his encounter with the paintings of Cézanne.

The sequence of letters bearing witness to this encounter was written in the fall of 1907 under the immediate impression of a memorial exhibition of works by Cézanne, who had died in the previous year. At the time, the poet called him "that peculiar and great old man" before whose paintings he had arrived at "strange and fortuitous insights" in the course of a few October

weeks. The letters reveal the dismay Rilke felt in front of these pictures. But because something is being expressed here that reaches beyond any artistically motivated occasion, the letters are hardly comparable to the book on Worpswede or the essay on Rodin. And yet, even though they lack the cohesive form of a monograph, and despite their seemingly incidental nature, the attentive reader will not fail to notice that these spontaneous records of the poet's astonishment and excitement make up a self-contained whole, and this without any subsequent editorial alterations. This has nothing to do with the thematic connection between the letters. A strong artistic intention informed the flow of expression, shaping it into a coherent whole with an exactness and an economy that almost appear intentional. Rilke himself had such a strong sense, later, of the unity of these unpremeditated, unself-consciously private, and deeply joyful utterances that he spoke of them to his wife only as "the" letters. For they basically are nothing other than that work on Cézanne which Rilke simultaneously yearned to write and shied away from for a long time, into his late years, and it is not surprising that he expressed the wish to see the letters published in book form one day. In their immediacy

and intimacy, their extraordinary density of expression, their intimations of what is unsayable, hints that yield lightning-like flashes of essential insight, they truly correspond to the subject of which they treat.

A thoughtful reading of the letters will gradually reveal how artfully interwoven these seemingly separate pieces are from beginning to end: their slow incipience with the first tentative statement of the theme, their gradually expanding crescendo and climax, their expiration in solid chords and intermittent pauses. The famous description of an imaginary morning walk through a palace in the old aristocratic quarter of Paris may at first strike a contemporary reader as no more than a precious ornamental arrangement of words, not unlike many other pieces of brocade embroidery that can be found in Rilke's early work; but what a magnificent light is cast on this introductory scene when Rilke returns to it later on—only in order to show that such a past must be "shed" if Cézanne's challenge is to be met...Such examples could be multiplied; there are glimpses into tradition which reveal the anticipated future, as in the Chardins Rilke visits in the Louvre; he looks at the stony perspectives of Paris and sees them receding far back into the shadowy blue of Egyptian hieroglyph seals; but he also looks at contemporaries like van Gogh and Rodin who all the more clearly define Cézanne's singularity, seeming digressions which serve to enhance the main theme, like musical ritardandi. The wave of seeing culminates at a height from which the gaze can sweep over all of humanity, then subsides in a kind of interrogative observation, and finally halts before particular pictures. Finally, after raising the question as to what could possibly follow after Cézanne, Rilke concludes that the only answer can be his own work.

Nothing could have been farther from Rilke's intentions than to write an art-historical treatise; he knew very well that he was not in a position to make scientific judgments and come to "correct" conclusions about objective facts. But because for him Cézanne—unlike all previous artistic experiences—was no longer an "evocation" but a pure face-to-face: precisely for this reason, his insights so thoroughly anticipated the findings of much later scientific studies of Cézanne that the art historians may very well have cause to retreat in shame, as Katharina Kippenberg has suggested.

The full range of Rilke's discovery can only

be intimated here. It is mainly an understanding of the decisive role "balance" plays in this art; that balance between the reality of nature and the reality of the image which was Cézanne's entire striving and which, when he achieved it, he likened to a "folding of hands." Rilke was well aware that this balance, this perfect equivalence (impossible without a previous insight into the inadequacy of mere "representation") was nothing less than a major event in the history of art. And there is a statement, the most important, perhaps, in the entire sequence of letters, which raises this idea above the level of aesthetic discourse: where he speaks of the "scales of an infinitely responsive conscience . . . which so incorruptibly reduced a reality to its color content that that reality resumed a new existence in a beyond of color, without any previous memories." Nowhere has the literature on art come closer to stating Cézanne's achievement than does Rilke in this sentence.

As Rilke's conversation with the painter Mathilde Vollmoeller confirms, he recognized the correspondence of object and color, the picture's answer to the mobile "motif," as one of the essential traits of Cézanne's painting. He repeatedly refers to this response of the work of art to

the natural phenomenon. Without any knowledge of the otherwise not very eloquent painter's remarks to the young poet Gasquet concerning the "equivalences" as the fruit of years of effort, Rilke was as cognizant of the importance of such a discovery as he was aware of the interdependence of colors within the paintings: "It's as if every place knew about all the others." However, the poet did not misconstrue Cézanne's "color logic" as a problem of craft and technique; he saw it as the very core of the creative process, profoundly vulnerable to intellectual interference, not to mention literary interpretation.

What Cézanne revealed to him could only be reinforced by a peculiar coincidence: he had just recently seen and intently observed a portfolio of reproductions of paintings by van Gogh. In order to fully understand his subsequent encounter with Cézanne, it is appropriate, even necessary, to focus on Rilke's descriptions of van Gogh's art in his first letters to Clara Rilke in October 1907—especially since he himself makes the connection later, after briefly reencountering several originals. The reader may recall, in this context, the last two entries in Hugo von Hofmannsthal's From the Letters of One Who Returned, published in 1907. These letters on the

subject of color deal with van Gogh and evince a shock of recognition that is reminiscent of Rilke's response to Cézanne. What gives one pause in this remarkable parallel, however, is that in both cases one of the principal forces of modern art was recognized by a poet. While Hofmannsthal, doubting the capacity of words, was overwhelmed by the "expressive" power of the simplest objects, Rilke perceives the silent strength of an "objective telling"-where even notions of "ugliness" and "beauty" lose their meaning, because what exists is being revealed as existent. The fact that he then grew mistrustful of a painter's all-too-knowing participation in his own creative process—and Rilke was not thinking only of van Gogh-proves how well he now understood that to burden a work of art with any ulterior motive, to impress it with one's hopes or wishes, is to weaken it and lay an obstacle in the path of a pure achievement. The viewer could have no other relationship to Cézanne's pictures than the one the artist had so arduously worked out for himself.

"The poets have learned how to see." This statement by the poetologist Richard Exner is borne out by Hofmannsthal's letters on color as well as by Rilke's *Letters on Cézanne*. However,

when Rilke makes the astonished remark that "suddenly one has the right eyes" (October 10), this does not refer exclusively to works of art. The change he feels, the newness and difference in his manner of seeing, does not only apply to the perception of paintings (let alone an external optical event). The peculiar transformation of the sense of sight is at the same time a transformation of the person standing in front of the pictures and writing about them. Or is it a change in the man that brings about this new way of seeing? The altered horizon of insight involves, in this seemingly minor context, a reclamation of language, an extension of its former boundaries that is never lost again. One might perhaps compare this with the innovations in painting that can be observed in Cézanne's pictures—most particularly those that (as Rilke remarks of the portraits) impressed most viewers as so "offensive" and "comical." It begins with almost casual but actually unusual word formations which leave behind the rules of speech sanctioned by everyday use and venture into utterly new territory. Rilke is aware of this process, for he comments on it in his letter of October 22, where he remarks how hard it is "when one tries to get very close to the facts"—and again the next day,

when he addresses the whole difficulty of trying to use words exactly, since they "feel so unhappy when made to denote the facts of a painting" and are "only too eager to return to themselves in the description of the man portrayed, for here's where their proper domain begins." Here, very close in time to Kandinsky's watercolors, Rilke is touching upon the problem of abstraction in painting. In countless border crossings, trespasses of which the reader is scarcely conscious, Rilke's language conquers new realms—not in play, not as an experiment, but in a tenacious struggle for the utmost precision. Malte Laurids Brigge's remark about the poet who hates the approximate was never more pertinent than here.

The meaning of that phrase may be illustrated with an example adduced by Rilke himself. In one of the letters, he speaks of the possibility of writing a monograph on the color blue, beginning with the pastels of Rosalba Carriera and the special blue of the eighteenth century, whereupon he mentions Cézanne's "very unique blue." In the course of the letters he produces a series of variations of this blue, formulations whose expressive power exceeds everything that has ever been said about this color. An October morning in Paris presents him with a

"blue that is unsupported anywhere" (October 11); two days later, in front of the pictures in the Salon, he speaks of "the good conscience of these reds, these blues." Thereupon, while crossing the Place de la Concorde, the poet becomes aware of "an ocean of cold barely-blue," while the houses in the background loom in a "blue dove-gray." The obelisk, around whose granite there is always "a glimmering of blond old warmth," holds "an ancient Egyptian shadow-blue" in its hieroglyphic hollows . . . Intensity of perception increases, and with it the wealth of nuances in the experiencing of blue: a "self-contained blue" (in van Gogh) is joined by a "listening blue" and a "thunderstorm blue" in Cézanne, with sky-blue and sea-blue as the only conventional mentions of the color. Until, in the end, in the second letter from Prague, a "bourgeois cotton blue" and a "light cloudy bluishness" evoke the whole scale of a single color as it was painted by the artist and named by the poet: from a "densely quilted blue" through "waxy blue," "wet dark blue," "juicy blue," to that slope of curved hills in a van Gogh: "full of revolt, Blue, Blue, Blue."

One need only consider how far this reaches beyond merely technical terms like indigo and Prussian blue to realize that the words are now

coming from a completely different realm of language. What is at issue here is that urgency Rilke mentions in one of the early letters (June 24), the sense of being required "to test and try ourselves against the utmost," while being at the same time constrained "not to express this utmost before it has entered into the work of art"-no matter whether the work be a painting or a poem. But that there is a freedom of communication in view of the finished work, as Rilke says in the same letter, is a truth he both proves and justifies in the Cézanne letters. Here we are offered a glimpse of the poet's ultimate responsibility. At the onset of an age that is preparing to proclaim its articles of faith in logograms and acronyms, these small and, one is tempted to say, humble steps taken in response to Cézanne's pictures are nothing other than a venturing into hitherto unexplored rooms, making language, "the house of being," a more habitable place.

It is only from this vantage that one can understand what Rilke meant when he spoke of "the turning point in this painting" and why he could even say that it wasn't the pictures as much as this turn that preoccupied him. The poet was well aware that he was not only observing a turning point in Western painting, that is, an event

that belongs in the annals of art history. But rather, he saw more clearly from day to day that the process revealed in these pictures demanded one's participation, not just one's understanding; a process that left no room for the distance of detached observation and comparison. A mere enjoyment of art such as it was known and nearly raised to a religion by the nineteenth century was no longer possible, as Rilke later told the Princess of Thurn and Taxis. But could a genuine "raptness" exist, as he believed, in the midst of a time that had been voided of all its symbols and myths? The poet did not take the teaching he had received as an artistic dogma; what had happened, and could happen again to anyone, was the same shock of recognition he had felt before the archaic torso of Apollo: "You must change your life."

Therein lies the meaning of that "turning point"—and it is basically an idle as well as inadequate question whether it was the pictures or the life of the painter that touched him more deeply. A closer look will reveal that the same issue was present in both: the ancient "enmity between life and the great work" (as Rilke put it in his "Requiem"), endured by the artist with such exemplary devotion. Cézanne evidently

knew what the issue was when, during the last thirty years of his life, he removed himself from everything that could "hook him" (the expression is Cézanne's), and when, for all his traditionbound and believing Catholicism, he stayed away from his mother's funeral in order not to lose a day's work. "That pierced me like an arrow . . . like a flaming arrow" (1921 to Baladine Klossovska). Cézanne's example revealed to Rilke his own existential conflict. He began to realize that his life must utterly belong to his work, and that he must never again be "delighted and awed" as it says in his "Testament"-except by his work. So that, having "expended" all his love in that work, he might some day produce things of such a purity as "was perhaps never achieved so perfectly as by that old man."

When Cézanne said of Rodin that he was a wonderful stonecutter whose every figure succeeded but who lacked an idea, a faith, he was not referring to artistic conceptions. Rilke sensed intuitively why the painter could no longer find any meaning in those "ideas" which nourished even a Rodin. Instead of parroting big words that no longer belong to anyone, Cézanne had to begin again from the bottom, subjecting himself to the daily effort of "being in front of the land-

scape and drawing religion from it"—a religion for which this churchgoing heathen did not have a name. But according to statements he himself made, he regarded the colors as numinous essences, beyond which he "knew" nothing, and "the diamond zones of God" remained white . . . Perhaps there is no other artist of our time to whom Heidegger's words apply so exactly: "We come too late for the gods and too early for being." That Rilke intuited something of this hidden anguish in Cézanne's greatness is occasionally hinted at in the letters when he speaks of "saintliness."

At the time, the poet was not yet ready to follow Cézanne's calling, and he experienced it as a failing. A year later, Rilke confessed in a painful, self-mortifying letter to his wife (September 8, 1908) that he had turned away from that challenge. The figure of Malte Laurids Brigge, whose "notebooks" are deeply connected to Rilke's new experiences—there are passages in Malte that are cited verbatim from the Letters—still stood before him, unrealized and unaccomplished, even though he had understood that "the chamberlain's death is the life of Cézanne." But that synthesizing and ordering power which Rilke found it so difficult to summon for the

completion of *Malte* had imparted itself abundantly to the making of that small work of art, the *Letters*.

A separate essay would have to be written on the impact of Cézanne on Rilke's poetry (up to the Elegies and beyond). But there is one instance worth mentioning here, for it has received little comment elsewhere. A careful reader of "Requiem for a Friend" (October 1908) will rediscover ideas and even specific formulations from the Cézanne letters in the famous verses about the friend's "possessionless" gaze, which was so "genuinely poor" that in the end "it did not even yearn for you: holy." There is a deeper personal connection in this: Paula Modersohn-Becker had experienced the master's work "like a great thunderstorm," years before Rilke-and it was thanks to her that at a decisive moment his eyes were opened to its message. "Perhaps I am being unfair-but all I saw was Cézanne," he wrote to her in the days of his most intense emotion. But the requiem places her forever in the light of the art to which they were both indebted.

These reflections would be incomplete if they did not make mention of Rilke's wife, whose presence and silent participation are sensible in every part of the *Letters*. Indeed, the letters attest,

more beautifully than any love letters could, that their recipient possessed a quality which the poet only very rarely encountered in his lifelong search for human companionship: she was his equal. If the *Letters on Cézanne* needed a dedication, it would have to be: "Property of Clara Rilke."

Heinrich Wiegand Petzet Worpswede, September 1961 Paris, February 1977

Letters on Cézanne

Hotel du Quai Voltaire, Monday, June 3, 1907

here. Everywhere else you see, and think: later—. Here they're almost one and the same. You're back again:¹ that's not surprising, not remarkable, not striking; it's not even a festive occasion; for a festival would already be an interruption. But this here takes you and goes further with you and goes with you to everything and right through everything, through lesser things and great things. All the things of the past rearrange themselves, line up in rows, as if someone were standing there giving out orders; and whatever is present is utterly and urgently present, as if prostrate on its knees and praying for you . . .

Four days earlier, Rilke had returned to Paris after a ten-month absence.

Paris VIe, 29, rue Cassette, Monday, June 24, 1907

... Early this morning your long letter, with all your thoughts . . . Surely all art is the result of one's having been in danger, of having gone through an experience all the way to the end, to where no one can go any further. The further one goes, the more private, the more personal, the more singular an experience becomes, and the thing one is making is, finally, the necessary, irrepressible, and, as nearly as possible, definitive utterance of this singularity . . . Therein lies the enormous aid the work of art brings to the life of the one who must make it, -: that it is his epitome; the knot in the rosary at which his life recites a prayer, the ever-returning proof to himself of his unity and genuineness, which presents itself only to him while appearing anonymous to the outside, nameless, existing merely as necessity, as reality, as being—.

So we are most definitely called upon to test and try ourselves against the utmost, but probably we are also bound to keep silence regarding this utmost, to beware of sharing it, of parting with it in communication so long as it has not entered the work of art: for the utmost represents nothing other than that singularity in us which no one would or even should understand, and which must enter into the work as such, as our personal madness, so to speak, in order to find its justification in the work and reveal the law in it, like an inborn drawing that is invisible until it emerges in the transparency of the artistic.— Nevertheless there are two liberties of communication, and these seem to me to be the utmost possible ones: the one that occurs face to face with the accomplished thing, and the one that takes place within actual daily life, in showing one another what one has become through one's work and thereby supporting and helping and (in the humble sense of the word) admiring one another. But in either case one must show results, and it is not lack of trust or withdrawal or rejection if one doesn't present to another the tools of one's progress, which have so much about them that is confusing and tortuous, and whose only value lies in the personal use one makes of them. I often think to myself what madness it would have been for van Gogh, and how destructive, if he had been forced to share the singularity of his vision with someone, to have someone join him in looking at his motifs before he had made his pictures of

1. Vincent van Gogh (1853–1890).

them, these existences that justify him with all their being, that vouch for him, invoke his reality. He did seem to feel sometimes that he needed such contact in letters (although there, too, he's usually talking of finished work), but no sooner did Gauguin,2 the comrade he'd longed for, the kindred spirit, arrive, than he had to cut off his ear in despair, after they had both determined to hate one another and at the first opportunity get rid of each other for good. (But that's just one side of it: feeling this from artist to artist. Another side is the woman and her part in it.) And a third (but only conceivable as a test for the upper grades) is the complication of the woman being an artist. Ah, that is an altogether new question, and ideas start nibbling at you from all sides as soon as you take just a few steps in their direction. I won't say any more about this today. —

^{2.} Paul Gauguin (1848–1903).

Paris VIe, 29, rue Cassette, June 28, 1907

. . . I must keep a steady course so long as the second part of my Rodin book isn't written yet.1 While I'm doing it, certain shifts of perspective must not be allowed to interfere as yet; they would destroy a great deal that was ordered and simple, but they would still not feel sufficiently familiar to me to allow a new and equally clear and, in the deepest sense, right relation of insights to arise. Naturally this second part will be the already existing lecture, virtually or completely unchanged—for in no way is this the time to say something new about Rodin. Instead, I must let the lecture stand as it is while I get it ready for the printer. I can still understand it completely, I think, although by now I'm beginning to understand that many perceptions in it may possibly be a response to the standards Rodin taught us to apply, rather than to the standards his work meets from case to case. I don't know anything about this yet; and that Rodin does not

1. The first part had appeared in 1903. Since then, Rilke's view of the sculptor's art had begun to change.

"think about" his work but remains within it: within the attainable—that is just what we felt made him so exceptional, this humble, patient path he trod through the real: and I have not yet found another faith to replace this one. In art, you can only stay within the "well done," and by your staying there, it increases and surpasses you again and again. It seems to me that the "ultimate intuitions and insights" will only approach one who lives in his work and remains there, and whoever considers them from afar gains no power over them. But all that already belongs in the area of personal solutions. Basically it's none of our business how somebody manages to grow, if only he does grow, if only we're on the trail of the law of our own growth

Paris VIe, 29, rue Cassette, September 13, 1907 (Friday)

. . . Never have I been so touched and almost gripped by the sight of heather as the other day, when I found these three branches in your dear letter. Since then they are lying in my Book of Images, penetrating it with their strong and serious smell, which is really just the fragrance of autumn earth. But how glorious it is, this fragrance. At no other time, it seems to me, does the earth let itself be inhaled in one smell, the ripe earth; in a smell that is in no way inferior to the smell of the sea, bitter where it borders on taste, and more than honeysweet where you feel it is close to touching the first sounds. Containing depth within itself, darkness, something of the grave almost, and yet again wind; tar and turpentine and Ceylon tea. Serious and poor like the smell of a begging monk and yet again hearty and resinous like precious incense. And the way they look: like embroidery, splendid; like three cypresses woven into a Persian rug with violet silk (a violet of such vehement moistness, as if it were the complementary color of the sun). You should see this. I don't believe these little twigs could

have been as beautiful when you sent them: otherwise you would have expressed some astonishment about them. Right now one of them happens to be lying on dark blue velvet in an old pen and pencil box. It's like a fireworks: well, no, it's really like a Persian rug. Are all these millions of little branches really so wonderfully wrought? Just look at the radiance of this green which contains a little gold, and the sandalwood warmth of the brown in the little stems. and that fissure with its new, fresh, inner barelygreen.—Ah, I've been admiring the splendor of these little fragments for days and am truly ashamed that I was not happy when I was permitted to walk about in a superabundance of these. One lives so badly, because one always comes into the present unfinished, unable, distracted. I cannot think back on any time of my life without such reproaches and worse. I believe that the only time I lived without loss were the ten days after Ruth's1 birth, when I found reality as indescribable, down to its smallest details, as it surely always is.—But presumably I would not be so receptive to the splendor of these little pieces of heather stemming from the extrava-

1. Rilke's daughter.

gance of the northern year if I hadn't just gotten over an urban summer. Perhaps, then, it wasn't completely in vain that I lived through the sort of cubicled summer where you're lodged as if in the smallest of those boxes that fit one into the other, twenty times. And you're sitting in the last one, crouching. Good God: how I labored last year; oceans, parks, woods, forest meadows: my longing for these is indescribable sometimes. Now that winter's already impending here. Those vaporous mornings and evenings are already starting, where the sun is merely the place where the sun used to be, and where in the yards all the summer flowers, the dahlias and the tall gladiolas and the long rows of geraniums shout the contradiction of their red into the mist. This makes me feel sad. It brings up desolate memories, one doesn't know why: as if the music of the urban summer were ending in dissonance, in a mutiny of all its notes; perhaps just because one has already once before taken all this so deeply into oneself and read its meanings and made it part of oneself, without ever actually making it.

Only this . . . for Sunday . . .

Paris VIe, 29, rue Cassette, Monday, September 16, 1907

... In all things, I am disposed to that patient waiting, that improvidence, in which the birds surpass us, according to Kierkegaard; the daily work, blindly and willingly performed, in all patience and with the *Obstacle qui excite l'ardeur* as its motto—this is the only kind of providence that does not interfere with God's wish to keep us in hand, night after night, that we may cover these pages without leaving a gap and without taking thought of the others who are held in that hand as well— . . .

Recently Claire⁸ said quite suddenly: "Vous serez illustre et riche" (and this on a day when I was very sad because of all the empty husks).—...

- 1. The reference is to "The Care of Poverty," the first of the five Christian sermons collected under the title *Heathenish Cares*. Rilke and his wife had read Kierkegaard's writings together in Paris.
- 2. This motto—meaning, approximately: "Resistance sparks the flame"—is taken from an old signet belonging to the Rilke family.
- 3. Waitress at Jouven's, a small restaurant on the Boulevard Montparnasse which Rilke frequently visited.

Paris VIe, 29, rue Cassette, On Sunday [September 29, 1907]

. . . What you experienced with the Portuguese grape is something I know so well: I am feeling it simultaneously in two pomegranates I recently bought from Potin; how glorious they are in their massive heaviness, with the curved ornament of the pistil still on the top; princely in their golden skins with the red undercoat showing through, strong and genuine, like the leather of old Cordovan tapestries. I have not yet tried to open them; they probably aren't ripe yet. When they are, I believe they easily burst of their own fullness and have slits with purple linings, like noblemen in grand apparel.-Looking at them, I too felt rising up within me the desire and presentiment of things foreign and southerly, and the lure of long voyages. But then, how much all of that is already within one, and how much more so when closing one's eyes tightly; I felt it again when I wrote the Corrida,1 which I had never seen: how I knew and how I saw it all! . . .

Paris VIe, 29, rue Cassette, October 2, 1907

. . . I'm sure it sounds quite unbelievable from a distance, but it's really true, the days here suddenly remind one of the sort of rain- and clouddays with very bright intervals that sometimes prematurely interrupt the late winter; you know the kind I am talking about: the ones where you say: all right, so much for the sleigh ride; or: that's the end of the ice-skating season; or: like that afternoon when I was standing by the window, up at the Seggerns,1 and you came back from that skating excursion in Bremen which had been unexpectedly called off. Clouds, loose clouds, wind, swift rains, and from an elevated clearing, suddenly, sunlight, as if cast with a reflector, strong, concentrated, and as if in a hurry, onto some wet thing that turned completely white in this blinding glare, and in all the windows brightness and sky. The suggestion was so great and so well calculated that these past few days I've often had the feeling of having a cold winter behind me and not the Parisian

1. Acquaintances of the Westhoffs in Oberneuland near Bremen.

summer, of which I have retained almost no memories at all...

. . . Yesterday, for the first time in many, many weeks, I saw someone—Mathilde Vollmoeller,2 who had recently returned from Holland. She had come to Jouven's after a long absence, and I almost minded meeting her, for I was feeling ill at the time and would have liked to curl up by myself and be quiet. In the course of our conversation she mentioned some van Gogh reproductions she had brought with her from Amsterdam, a whole portfolio, and asked me whether I didn't want to see them. I did. Then I suggested we get together that same afternoon, since that was most convenient for her. I forced myself to go, and the existence and quietness and healthy containment of another life, the possibility of hearing the sound of talk after so much solitude, the other's talk as well as one's own, and of being pampered with a cup of tea: all of this had the very best effect on me. Especially, of course, the reproductions of those tireless, touching works which spoke with such immediacy of the duty of being healthy and doing something comparable; in part, these are the

2. A German painter.

same things discussed in the letters to his brother (which are in the possession of this brother's widow—hundreds of them).

But it is not so easy to live one's life differently here, from day to day, and I have to admit that Paris has been trying to shake me off for some time, like a horse its rider. You yourself know this moment when incompatibility sets in: we experienced it several times. It's made up of little admonitions, but in the end it gets very clear indeed...

. . . I became so tired from writing that I just heedlessly pushed my letter to an end on the eighth page . . . Since then I've gone out to drink my milk, Boulevard Montparnasse. Before that I spent a good, quiet hour: under the protection and in the feeling of yesterday's letter from you, drinking my last sip of tea, face to face with the van Gogh reproductions. We hadn't gone through the whole portfolio yesterday, and so I was permitted to take them home with me, and now I have them to myself for a few days. And had them today, and gained such joy and insight and strength from them. These are plain, not especially sophisticated but very appealing, reproductions of forty works, twenty of them dating back to the time before van Gogh came to France. Paintings, drawings, and lithographs, especially paintings. Blooming trees (as only Jacobsen¹ could do them), plains in which human figures are distributed and moved about far and wide;

^{1.} The Danish poet Jens Peter Jacobsen (1847–1885), whom Rilke once called his "tutelary spirit."

and it still goes farther back behind them into the sheet and gets all bright at its farthest reach, as if continuing beyond the limits of the page. Or an old horse, a completely used up old horse: and it is not pitiful and not at all reproachful: it simply *is* everything they have made of it and what it has allowed itself to become. Or a garden, or a park, which is seen and shown with the same utter lack of prejudice or of pride; or, simply, things, a chair for instance, nothing but a chair, of the most ordinary kind: and yet, how much there is in all this that reminds one of the "saints" he promised himself and resolved to paint at some much later time! (In that one letter.) Good night...

Paris VIe, 29, rue Cassette, October 3, 1907

... Would that you were sitting with me on this cold uncaring rainy day that is so reluctant to pass, and which is now finally (as I noticed at Jouven's) filling other people with dismay and confusion as well. Would that you were sitting with me in front of the van Gogh portfolio (which I am returning with a heavy heart). It did me so much good these two days: it came just at the right moment. How much you would see in it that I can't see yet. You probably wouldn't even have read the little biographical notice of no more than ten lines that precedes the table of contents; you would have simply relied on your ability to see. But this notice is very, very matter-of-fact and yet so strangely meaningful. An art dealer, and since he somehow realizes after three years that that wasn't it, a little schoolteacher in England. And in the midst of that the decision: to become a priest. He goes to Brussels to learn Greek and Latin. But why the detour? Aren't there people somewhere who don't expect their priest to know Greek or Latin?: And so he becomes what is called an evangelist, and he goes

to a mining district and tells the people the story of the gospel. And while he talks, he begins to draw. And finally he doesn't even notice how he's stopped talking and is only drawing. And from then on, that's all he does, until his last hour, when he decides to stop everything because he might not be able to paint for weeks; at that point it seems natural to him to give up everything, especially life. What a biography. Is it really true that everyone is now acting as if they understood this and the pictures that came out of it? Shouldn't art dealers and also art critics be really more perplexed about or else more indifferent to this dear zealot, in whom something of the spirit of Saint Francis was coming back to life? I am surprised by his quick rise to fame. Ah, how he, too, renounced and renounced. His selfportrait in the portfolio looks shabby and tormented, almost desperate, but not devastated: the way a dog looks when it's in a bad way. He holds out his face and you take note of the fact: he's in a bad way, day and night. But in his paintings (the arbre fleuri) poverty has already become rich: a great splendor from within. And that's how he sees everything: as a poor man; just compare his parks. These too are expressed with such quietness and simplicity, as if for poor

people, so they can understand; without going into the extravagance that's in these trees; as if to do that would already be taking sides. He isn't on anyone's side, isn't on the side of the parks, and his love for all these things is directed at the nameless, and that's why he himself concealed it. He does not show it, he has it. And quickly takes it out of himself and puts it into the work, into the innermost and incessant part of the work: quickly: and no one has seen it! That's how one feels his presence in these forty pages: now, haven't you been next to me after all, just a bit, in front of these pictures? . . .

Paris VIe, 29, rue Cassette, October 4, 1907 (Friday)

. . . one is still so far away from being able to work at all times. Van Gogh could perhaps lose his composure, but behind it there was always his work, he could no longer lose that. And Rodin, when he's not feeling well, is very close to his work, writes beautiful things on countless pieces of paper, reads Plato and follows him in his thought. But I have a feeling that this is not just the result of discipline or compulsion (otherwise it would be tiring, the way I've been tired from working in recent weeks); it is all joy; it is natural well-being in the one thing that surpasses everything else. Perhaps one has to have a clearer insight into the nature of one's "task," get a more tangible hold on it, recognize it in a hundred details. I believe I do feel what van Gogh must have felt at a certain juncture, and it is a strong and great feeling: that everything is yet to be done: everything. But this devotion to what is nearest, this is something I can't do as yet, or only in my best moments, while it is at one's worst moments that one really needs it. Van Gogh could paint an Intérieur d'hôpital, and in his

most anxious days he painted the most disquieting objects. How else could he have survived. This is what has to be attained, and I have a feeling it can't be forced. It must come out of insight, from pleasure, from no longer being able to postpone the work in view of all the many things that have to be done. Ah, if only one did not have comforting memories of times spent without working. Memories of lying still and taking comfort. Memories of hours spent in simple waiting, or leafing through old illustrations, or reading some novel or other -: and heaps of memories like these all the way back to childhood. Whole realms and districts of life lost, lost even for the retelling, because of the seduction that still may inhere in their idleness. Why? If only one had nothing but memories of work from the beginning: how firm the ground would be under one's feet; one would stand. But this way, there isn't a moment when one isn't sinking in somewhere. That it's this way inside, too: double world1-that's the worst thing of all. Sometimes I walk past little shops, on the rue de Seine for example: secondhand shops, or

1. "Double World" is the title of a novella by Jens Peter Jacobsen. See Jacobsen's letter to Edvard Brandes, Oct. 28, 1979. little secondhand bookstores or places that sell copper engravings, with their windows filled to the brim: nobody ever goes in there, it seems they don't do any business at all; but when you look inside, you see them sitting and reading, unconcerned (and yet they're not rich); not a thought about tomorrow, no worrying about success, a dog sitting in front of them, good-natured, or a cat that makes the stillness around them even greater by brushing along the rows of books as if to wipe the names off their backs.

Ah, if only this were enough: sometimes I dream of buying a full shop window like that and sitting down behind it with a dog for twenty years. In the evening there would be light in the back room, the front would be dark, and we would be sitting in back together, the three of us, eating; I've noticed how, when you look in from the street, it always looks like a Last Supper, so great and solemn through the dark room. (But this way, one always has to contend with all the worries, the great ones and the little ones.) . . . You know how I mean that: without complaining. After all, it's good the way it is, and it's going to get even better . . .

Paris VIe, 29, rue Cassette, Sunday afternoon [October 6, 1907]

... Sounds of rain and of bells striking the hour: this makes a pattern, a Sunday pattern. If you didn't know it: this would have to be Sunday. That's how it sounds in my quiet street. But how much Sunday there was in the old aristocratic quarter through which I walked this morning. The old closed-down hotels in the Faubourg Saint-Germain with their white-gray shutters, their discreet gardens and courtyards, the locked ironwork gates and heavy, tight-shutting doors. Some of them were very haughty and sophisticated and inaccessible. These may have been the Talleyrands, the de la Rochefoucaulds, unapproachable gentry. But then came a street that was just as quiet with somewhat smaller houses, no less noble in their manner and quite reserved. One of the gates was just about to close; a servant in his morning livery turned around again and looked at me carefully and thoughtfully. And at that same moment it seemed to me that it would have taken only a very slight shift in the pattern of things at some time in order for him to recognize me and step back and hold open the door. In order for an old lady to be up there, a grand'-

mère who would make it possible to receive her favorite grandson even at this early hour. With a smile, quite affectionate herself, the familiar lady's maid would carry out the order and lead the way through the draped suite of rooms, inwardly turned back and hurrying for sheer eagerness and uneasiness at having to walk ahead of me. A stranger passing through in this manner would not understand anything; but I would feel the presence of all the interrelated things: the gaze of portraits, the dials of musical clocks and the content of mirrors in which the clear essence of this twilight is preserved. In an instant I would have recognized the light-filled salons, which are quite bright within the darkness. And that one room which seems darker because the family silver in the back has absorbed all the light. And the solemnity of all this would confer itself upon me and carefully prepare me for the old lady in violet white, whom one can't picture in the mind's eye from one time to the next because she's made up of so many things----

I walked through the quiet street and was still immersed in my imaginings when I saw some beautiful old silver in a confectioner's shop window. Pitchers with slightly drooping, plump silver flowers on the lids and fantastic reflections in their curved prows.

Now it is hard to believe that this was the way that led to the Salon d'Automne.1 But finally I did arrive at the bright and colorful picture market, which, for all its straining to make an impression, did not dispel my inner mood. The old lady persisted, and I felt how much it would be beneath her dignity to come here and look at these pictures. I wondered whether I might not find something I could tell her about after all, and found a room with pictures by Berthe Morizot (Manet's sister-in-law)² and a wall with works by Eva Gonzalès (Manet's student).3 Cézanne is no longer possible for the old lady; but for us he is valid and moving and important. He too (like Goya) 4 painted the walls of his studio in Aix with his imaginings (some photographs of these, by Druet,⁵ were exhibited here). This much about my Sunday to you...

1. The Autumn Salon was founded in 1903 and took place annually in the Grand Palais, a building constructed on the Champs-Élysées for the 1900 World's Fair. In 1907, a retrospective of Belgian art was shown in addition to the two rooms devoted to the memory of Cézanne.

2. Berthe Morizot (1840–1895), married to Eugène Manet, the brother of the painter Édouard Manet.

3. Eva Gonzalès (1850–1883), daughter of the novelist Emmanuel Gonzalès.

4. Francisco Goya y Lucientes (1746–1828).

5. E. Druet, art dealer in Paris.

Paris VIe, 29, rue Cassette, October 7, 1907 (Monday)

- . . . I went back to the Salon d'Automne this morning, and found Meier-Graefe¹ in front of the Cézannes again . . . Count Kessler² was there too and told me many beautiful and honest things about the new Book of Images, which he and Hofmannsthal had read aloud to each other. All of this happened in the Cézanne room, which makes an immediate claim on one's attention with its powerful pictures. You know how much more remarkable I always find the people walking about in front of paintings than the paintings themselves. It's no different in this Salon
- 1. Julius Meier-Graefe (1867–1937), writer of books on art and spirited champion of impressionism. Among his many popular monographs is a book on the life and work of Cézanne.
- 2. Harry Graf Kessler (1868–1937), a diplomat, writer, and patron of the arts who counted numerous artists and poets (Munch, Maillol, Hofmannsthal) among his friends. He founded the Cranach-Presse in Weimar, where famous bibliophile books were published (e.g., Vergil's *Eclogues* with Maillol's woodcuts). Kessler's journals (1918–1937) were published by Insel-Verlag in 1961.

d'Automne, except for the Cézanne room. Here, all of reality is on his side: in this dense quilted blue of his, in his red and his shadowless green and the reddish black of his wine bottles. And the humbleness of all his objects: the apples are all cooking apples and the wine bottles belong in the roundly bulging pockets of an old coat. Fare well...

Paris VIe, 29, rue Cassette, October 8, 1907

. . . It's strange to walk through the Louvre after two days in the Salon d'Automne: you notice two things right away: that every insight has its parvenus, upstarts who make a hue and cry as soon as they catch on,-and then, that perhaps these aren't particularly illuminating insights at all. As if these masters in the Louvre didn't know that painting is made up of color. I've looked at the Venetians: they're of an indescribably radical colorfulness; you can feel how far it goes in Tintoretto.1 Almost farther than with Titian.2 And so on into the eighteenth century, where the only thing separating their color scale from Manet's is the use of black. Guardi³ has it, incidentally; it was unavoidable, right there in the middle of all that brightness, ever since the laws against luxurious display decreed the use of black gondolas. But he uses it more as a dark mirror than as a color; Manet was the first-encouraged

^{1.} Jacopo Robusti, also known as Tintoretto (1518–1594).

^{2.} Tiziano Vecellio (1488–1576).

^{3.} Francesco de Guardi (1712-1793).

by the Japanese, certainly—to give it equal value among the other colors. Contemporaneously with Guardi and Tiepolo,4 a woman too was painting, a Venetian, who came to all the courts and whose name was among the most celebrated of her time: Rosalba Carriera.⁵ Watteau⁶ knew about her, and they exchanged a few pastels, her self-portraits perhaps, and held one another in tender regard. She traveled a lot, painted in Vienna, and one and a half hundred of her works are still preserved in Dresden. Three portraits are in the Louvre. A young lady, her face raised up by the straight neck and then turned naively toward the viewer, and in front of her décolleté lace dress she holds a small clear-eyed capuchin monkey who is peering out from the lower edge of the half-length portrait as eagerly as she's looking out on top, just a bit more indifferently. He's reaching out with one small perfidious black hand to draw her tender, distracted hand into the picture by one slender finger. This is so full of one period that it is valid for all times. And it is lovely and lightly painted, but really painted. There's also a blue cloak in the picture and

- 4. Giovanni Battista Tiepolo (1696-1770).
- 5. Rosalba Carriera (1675–1757).
- 6. Jean-Antoine Watteau (1684–1721).

one whole lilac-white gillyflower stem, which, strangely, takes the place of a breast decoration. And I noticed that this blue is that special eighteenth-century blue that you can find everywhere, in La Tour, in Peronnet, but to Chardin, where it still hasn't lost its elegance, even though he uses it rather heedlessly in the ribbon of his peculiar hood (in the self-portrait with the hornrimmed pince-nez). (I could imagine someone writing a monograph on the color blue, from the dense waxy blue of the Pompeiian wall paintings to Chardin and further to Cézanne: what a biography!) For Cézanne's very unique blue is descended from these, it comes from the eighteenth-century blue which Chardin stripped of its pretension and which now, in Cézanne, no longer carries any secondary significance. Chardin was the intermediary in other respects, too; his fruits no longer remind you of a gala dinner, they're scattered about on the kitchen table and don't seem to care whether they are beautifully eaten or not. In Cézanne they cease

- 7. Maurice-Quentin La Tour (1704–1788).
- 8. Rilke means Jean-Baptiste Perronneau (1731–1783).
- 9. Jean-Baptiste Siméon Chardin (1699–1799). His self-portrait with pince-nez hangs in the Louvre.

to be edible altogether, that's how thinglike and real they become, how simply indestructible in their stubborn thereness. When you see Chardin's portraits of himself, you think he must have been a queer old lone wolf. Perhaps tomorrow I'll tell you to what an extent and how sadly this was the case with Cézanne. I know a few things from his last years when he was old and shabby and children followed him every day on his way to his studio, throwing stones at him as if at a stray dog. But inside, way inside, he was marvelously beautiful, and every once in a while he would furiously shout something absolutely glorious at one of his rare visitors. You can imagine how that happened. Fare well . . .; that was today . . .

Paris VIe, 29, rue Cassette, October 9, 1907

. . . today I wanted to tell you a little about Cézanne. With regard to his work habits, he claimed to have lived as a Bohemian until his fortieth year. Only then, through his acquaintance with Pissarro,1 did he develop a taste for work. But then to such an extent that for the next thirty years he did nothing but work. Actually without joy, it seems, in a constant rage, in conflict with every single one of his paintings, none of which seemed to achieve what he considered to be the most indispensable thing. La réalisation, he called it, and he found it in the Venetians whom he had seen over and over again in the Louvre and to whom he had given his unreserved recognition. To achieve the conviction and substantiality of things, a reality intensified and potentiated to the point of indestructibility by his experience of the object, this seemed to him to be the purpose of his innermost work; old, sick, exhausted every evening to the edge of

1. Camille Pissarro (1830–1903) was a friend of Cézanne's who exerted a strong influence on him in the seventies.

collapse by the regular course of the day's work (often he would go to bed at six, before dark, after a senselessly ingested meal), angry, mistrustful, ridiculed and mocked and mistreated each time he went to his studio,—but celebrating Sunday, attending Mass and Vespers as he had in his childhood, and very politely requesting some slightly better food from Madame Brémond, his housekeeper—: hoping nevertheless from day to day that he might reach that achievement which he felt was the only thing that mattered. And all the while (assuming one can trust the testimony of a not very likable painter² who associated with everyone for a while) he exacerbated the diffi-

2. Rilke is referring to Émile Bernard, one of the few artists who had any dealings with Cézanne during his later years. His "Souvenirs sur Cézanne" first appeared in the *Mercure de France*, September/October 1907. Rilke comments on this work in his last letter to Paula Modersohn-Becker on October 21, 1907: "I'm sending the catalogue of the Salon along with two issues of the 'Mercure,' containing some notes on Cézanne by a not very pleasant reporter (the painter Émile Bernard), behind whose back, however, one may glean a few factual data...

"Cézanne was an event which most people no longer had the patience to experience, especially the painters didn't want to . . . But perhaps I'm being unfair. All I saw was Cézanne."

culty of his work in the most willful manner. While painting a landscape or a still life, he would conscientiously persevere in front of the object, but approach it only by very complicated detours. Beginning with the darkest tones, he would cover their depth with a layer of color that led a little beyond them, and keep going, expanding outward from color to color, until gradually he reached another, contrasting pictorial element, where, beginning at a new center, he would proceed in a similar way. I think there was a conflict, a mutual struggle between the two procedures of, first, looking and confidently receiving, and then of appropriating and making personal use of what has been received; that the two, perhaps as a result of becoming conscious, would immediately start opposing each other, talking out loud, as it were, and go on perpetually interrupting and contradicting each other. And the old man endured their discord, ran back and forth in his studio, which was badly lit because the builder had not found it necessary to pay attention to this strange old bird whom the people of Aix had agreed not to take seriously. He ran back and forth in his studio with green apples scattered about, or went out into his garden in despair and sat. And before him lay the small

town, unsuspecting, with its cathedral; a town for decent and modest burghers, while he-just as his father, who was a hat maker, had foreseen —had become different: a Bohemian: that's how his father saw it and what he himself believed. This father, knowing that Bohemians live and die in misery, had determined to work for the son, had become a kind of small banker to whom people brought their money ("because he was honest," as Cézanne said), and it was thanks to these financial precautions that Cézanne later had the means to continue painting without interruption. Perhaps he went to his father's funeral; he loved his mother too, but when she was buried, he wasn't there. He was engaged "sur le motif," as he called it. That's how important work was for him already, and he couldn't afford to make an exception, not even this one, which surely must have commended itself to his piety and simplicity as an important occasion.

He became well known in Paris, and gradually his fame grew. But he had nothing but mistrust for any progress that wasn't of his own making (that others had made for him, quite aside from the question of *how* they had made it); he remembered only too well how thoroughly Zola (a fellow Provençal, like himself, and a close ac-

quaintance since early childhood) had misinterpreted his fate and his aspirations in L'oeuvre.3 From then on, any kind of scribbling was out: "Travailler sans le souci de personne et devenir fort—" he once shouted at a visitor. But when the latter, in the middle of a meal, described the novella about the Chef d'Oeuvre inconnu (I told you about it once), where Balzac, with unbelievable foresight of future developments, invented a painter named Frenhofer who is destroyed by the discovery that there really are no contours but only oscillating transitionsdestroyed, that is, by an impossible problem—, the old man, hearing this, stands up, despite Madame Brémond, who surely did not appreciate this kind of irregularity, and, voiceless with agitation, points his finger, clearly, again and again, at himself, himself, himself, painful though that may have been. Zola had understood nothing; it was Balzac who had foreseen or forefelt that in painting you can suddenly come upon something so huge that no one can deal with it.

And yet, the next day, he attacked the prob-

^{3.} Zola's novel appeared in 1886. The book's publication put an end to Cézanne and Zola's friendship.

lem again, as always; every morning, he would get up at six, walk through town to his studio and stay there till ten; return along the same road to take his meal; eat and set off again, sometimes a half hour's walk past the studio, "sur le motif" in a valley before which the mountain range of Sainte Victoire rose up indescribably with all its thousand challenges. There he would sit for hours, occupied with finding and incorporating the "plans" (curiously, he refers to them again and again with the same word Rodin used). He generally reminds one of Rodin in his statements. For example when he complains about the way his old city is being destroyed and disfigured every day. The only difference is that, where Rodin, with his great, self-confident equilibrium, comes out with a matter-of-fact remark, Cézanne, sick, old, and isolated, is seized by a rage. Coming home in the evening, he'll start boiling up over some change, work himself into a fury, and finally, noticing how it exhausts him to be so angry, he'll promise himself: I'll stay home; work, just work, nothing else.

And then, from these changes for the worse

^{4. &}quot;Plans" was Rodin's expression for animated planes. Cf. Rilke's explanation in his Rodin monograph.

in the little town of Aix, he makes a horrified inference about what must be happening elsewhere. Once, when the conversation turned to present conditions, to industry and all that, he burst out: "with terrible eyes": Ça va mal . . . C'est effrayante la vie!

Out there, something vaguely terrible on the increase; a little closer by, indifference and mockery, and then suddenly this old man in his work, painting nudes only from old sketches he made forty years ago in Paris, because he knows that Aix would not permit him the use of a model. "At my age," he says-"I couldn't get a woman below the age of fifty, and I know it wouldn't even be possible to find such a person in Aix." So he uses his old drawings as models. And lays his apples on bed covers which Madame Brémond will surely miss some day, and places a wine bottle among them or whatever happens to be handy. And (like van Gogh) he makes his "saints" out of such things; and forces them—forces them to be beautiful, to stand for the whole world and all joy and all glory, and he doesn't know whether he has succeeded in making them do it for him. And sits in the garden like an old dog, the dog of this work that is calling him again and that beats him and lets him starve. And yet he's

attached with his whole being to this incomprehensible master, who only lets him return to the good Lord on Sundays, as if to his original owner, just for a while.—(And the people outside say: "Cézanne," and the gentlemen in Paris underscore his name when they write it and are proud of being well informed—.)

I wanted to tell you about all this, because it connects in a hundred places with a great deal that surrounds us, and with ourselves.

It's still raining extravagantly outside. Fare well... tomorrow I'll speak of myself again. But you know how much of myself was in what I told you today...

Paris VIe, 29, rue Cassette, October 10, 1907

. . . . if one didn't know (and know more and more) that without resistance there would be no movement and none of the rhythmic circulation of all the things we encounter, this would be very confusing and upsetting: that because of the money you won't be coming to see the Salon d'Automne (which I'm so preoccupied with) and that for the same reason I'll probably have to forego my own trip, even though inwardly, in my expectation, it's still awaiting me, strong and undamaged . . .

Meanwhile I'm still going to the Cézanne room, which, I suppose, you can somewhat imagine by now, after yesterday's letter. I again spent two hours in front of a few pictures today; I sense this is somehow useful for me. Would it be instructive for you? I can't really say it in one breath. One can really see all of Cézanne's pictures in two or three well-chosen examples, and no doubt we could have come as far in understanding him somewhere else, at Cassirer's¹ for

1. Paul Cassirer (1871–1926), Berlin art dealer and publisher. Rilke had already seen pictures by Cézanne in

instance, as I find myself advancing now. But it all takes a long, long time. When I remember the puzzlement and insecurity of one's first confrontation with his work, along with his name, which was just as new. And then for a long time nothing, and suddenly one has the right eyes . . . I would almost prefer, if you should be able to come here some day, to lead you to the Déjeuner sur l'herbe,2 to this female nude seated among the green mirrorings of a leafy wood, every part of which is Manet, shaped by an indescribable expressive capacity which suddenly, after many unavailing attempts, came about, was there, succeeded. All his means were released and dissolved in succeeding: you'd almost think no means were used at all. I stood in front of it for a long time yesterday. But it's valid, the miracle, only for one person, every time; only for the saint to whom it happens. Cézanne had to start all over again, from the bottom . . . Fare well until the next time...

Berlin in the fall of 1900. (Letter dated November 8, 1900, to Clara Westhoff: ". . . and the pictures of a peculiar Frenchman, Cézanne.")

^{2.} Manet's famous *Déjeuner sur l'herbe* was rejected by the Salon in 1863, after which it was shown in the Salon des Refusés. It is hanging in the Louvre today.

Paris VIe, 29, rue Cassette, October 11, 1907 (Friday)

spacious, wafting, cool. In the east behind Notre-Dame and Saint-Germain l'Auxerrois all of the last, gray, half-discarded days had bunched together, and before me, over the Tuileries, toward the Arc de l'Étoile, lay something open, bright, weightless, as if this were a place leading all the way out of the world. A large fan-shaped poplar, shedding its leaves, played in front of this completely supportless blue, in front of the incomplete, exaggerated designs of a vastness which the good Lord holds out before him without any knowledge of perspective.

Since yesterday it's no longer so drenchingly monotonous. Something is blowing, is changing, and once in a while there are moments of a kind of profligate joy. Yesterday, when I first saw the little moon standing again in the mother-of-pearl sky, I understood that it was he that brought about the change and vouches for it. Where will I be when he has grown up to the age of decision and holds court in the autumnal sky?—...

Paris VIe, 29, rue Cassette, October 12, 1907¹

... Leaving the house is less hard than it was last week. To think what a little moon like that can accomplish. These are the days where one is surrounded by everything, luminous, light, barely intimated in the bright air and yet distinct; even what is nearest has the sound of distance about it, is removed and only indicated, instead of being put there, as usual; and all the things that are related to distance—the river, the bridges, the long streets, and the extravagant squares—have been absorbed and hugged close by that distance, are painted upon it, as if on silk. You can feel what a light-green carriage can be on the Pont-Neuf or some red that can't contain itself, or simply a poster on the fire wall of a pearl-gray group of houses. Everything is simplified, reduced to a few regular light planes, like the face in a portrait by Manet. And nothing is insignificant and superfluous. The bouquinistes on the quai are opening their boxes, and the fresh or withered yellow of the books, the violet brown of the

1. Rilke included the beginning of this letter, virtually unchanged, in *The Notebooks of Malte Laurids Brigge*.

volumes, the green of a portfolio: everything is right, is valid, participates, contributes its sound in the unity of bright correspondences.

The other day I asked Mathilde Vollmoeller to go through the Salon with me, so that I could see my impression in the presence of someone whom I believe to be quiet and not distracted by literature. Yesterday we went there together. Cézanne didn't let us move on to anything else. I notice more and more what an event this is. But imagine my surprise when Miss V., with her painterly training and eye, said: "He sat there in front of it like a dog, just looking, without any nervousness, without any ulterior motive." And she said some very good things about his manner of working (which one can decipher in an unfinished picture). "Here," she said, pointing to one spot, "this is something he knew, and now he's saying it (a part of an apple); right next to it there's an empty space, because that was something he didn't know yet. He only made what he knew, nothing else." "What a good conscience he must have had," I said. "Oh yes: he was happy, somewhere deep inside . . ." And then we looked at "artistic" things which he may have made in Paris, when he was associating with others, and compared them with those that were

unmistakably his own; compared them, that is, with regard to color. In the former, color was something separate; later he somehow takes it personally, as no one has ever taken color before, simply for making the object. The color is totally expended in its realization; there's no residue. And Miss V. said very significantly: "It's as if they were placed on a scale: here the object, there the color; never more, never less than is needed for perfect balance. It might be a lot or a little, that depends, but it's always the exact equivalent of the object." I would never have thought of this; but it is eminently right and illuminating. I also noticed yesterday how unselfconsciously different they are, how unconcerned with being original, confident of not getting lost with each approach toward one of nature's thousand faces; confident, rather, of discovering the inexhaustible nature within by seriously and conscientiously studying her manifold presence outside. All of this is very beautiful . . .

Paris VIe, 29, rue Cassette, October 13, 1907 (Sunday)

. . . It's again the same constant raining I've already described to you so often; as if the sky had merely cast one bright glance into space and then gone on perusing the even lines of rain. But one doesn't so easily forget that beneath the dull wash there is this light and this depth you could see, just yesterday: now at least one knows about it.

Early this morning I read about your autumn, and all the colors you brought into your letter were changed back in my feelings and filled my mind to the brim with strength and radiance. Yesterday, while I was admiring the dissolving brightness of autumn here, you were walking through that other autumn back home, which is painted on red wood, as this one's painted on silk. And the one reaches us as much as the other; that's how deeply we are placed on the ground of all transformation, we most changeable ones who walk about with the urge to comprehend everything and (because we're unable to grasp it) reduce immensity to the action of our heart, for fear that it might destroy us. If

I were to come and visit you, I would surely also see the splendor of moor and heath, the hovering bright greens of meadows, the birches, with new and different eyes; and though this transformation is something I've completely experienced and shared before, in part of the Book of Hours,1 nature was then still a general occasion for me, an evocation, an instrument in whose strings my hands found themselves again; I was not yet sitting before her; I allowed myself to be swept away by the soul that was emanating from her; she came over me with her vastness, her huge exaggerated presence, the way the gift of prophesy came over Saul; exactly like that. I walked about and saw, not nature but the visions she gave me. How little I would have been able to learn from Cézanne, from van Gogh, then. I can tell how I've changed by the way Cézanne is challenging me now. I am on the way to becoming a worker, on a long way perhaps, and probably I've only reached the first milestone; but still, I can already understand the old man who walked somewhere far ahead, alone, followed only by children who threw stones (as I once

1. The second part of the *Book of Hours* ("Of Pilgrimage") was written from September 18 to 25, 1901, in Westerwede near Worpswede.

described it in the fragment about the solitary ones).2 Today I went to see his pictures again; it's remarkable what an environment they create. Without looking at a particular one, standing in the middle between the two rooms, one feels their presence drawing together into a colossal reality. As if these colors could heal one of indecision once and for all. The good conscience of these reds, these blues, their simple truthfulness, it educates you; and if you stand beneath them as acceptingly as possible, it's as if they were doing something for you. You also notice, a little more clearly each time, how necessary it was to go beyond love, too; it's natural, after all, to love each of these things as one makes it: but if one shows this, one makes it less well; one judges it instead of saying it.3 One ceases to be impartial; and the very best-love-stays outside the work, does not enter it, is left aside, untranslated: that's how the painting of sentiments came about

^{2.} This fragment was first published in the *Insel-Almanach auf das Jahr 1956* and was later included in the collected works.

^{3.} See "Requiem for a Friend," Complete Works I, p. 649, lines 24–27. Cf. also the end of his letter to Clara Rilke of October 3, 1907: "He (van Gogh) isn't on anyone's side . . . his love for all these things is directed at the nameless . . . He does not show it, he has it."

(which is in no way better than the painting of things). They'd paint: I love this here; instead of painting: here it is. In which case everyone must see for himself whether or not I loved it. This is not shown at all, and some would even insist that love has nothing to do with it. It's that thoroughly exhausted in the action of making; there is no residue. It may be that this emptying out of love in anonymous work, which produces such pure things, was never achieved as completely as in the work of this old man; his inner nature, having grown mistrustful and cross, helped him to do it. He certainly would not have shown another human being his love, had he been forced to conceive such a love; but with this disposition, which was completely developed now, thanks to his reclusive eccentricity, he now turned to nature and knew how to swallow back his love for every apple and put it to rest in the painted apple forever. Can you imagine what that is like, and what it's like to experience this through him? I've received the first proofs4 from the Insel Verlag. In the poems, there are instinctive beginnings toward a similar objectivity. I'm leaving the "gazelle" as it is: it's good. Fare well . . .

- 4. The proofs for the New Poems.
- 5. See Complete Works I, p. 506. The poem was written on July 17, 1907.

Paris VIe, 29, rue Cassette, October 15, 1907

by Rodin; they were expected in the Salon d'Automne, there's one page in the catalogue announcing them as a whole; but the one room that seemed to be originally reserved for them has long been filled up with bad merchandise. And suddenly today, on the big boulevards, I read: they're at Bernheim-jeune, more than one hundred and fifty of them. As you can imagine, I dropped everything else and went to Bernheim. There indeed were the drawings, many pages

1. Bernheim Jeune: a Parisian art dealer who organized important exhibitions of modern artists in his gallery. It was there that Rilke saw the exhibition of Cézanne watercolors on the recommendation of Paula Modersohn-Becker. This exhibition of June 16–29, 1907, comprised more than fifty works. Rilke's letter to Paula Modersohn-Becker of June 28, 1907:

"Bernheim Jeune is exhibiting Cézanne watercolors, which I saw yesterday. As I looked at them I remembered your telling me about Cézanne, and about the 'beautiful things from his youth' (those were your words, literally), and about the planned exhibition of his pictures in the next Salon d'Automne . . . the watercolors are very beautiful. Just as confident as the paintings, and as light as the

which I already knew, which I had helped frame in those cheap white-gold frames that were ordered in such enormous quantities, back then. Which I knew: but did I really know them? There was so much in them that seemed different to me (is it Cézanne? Is it the passing of time?); what I had written about them two months ago had receded to the outer limits of validity. It still was valid, somewhere; but, as always when I fall into the error of writing about art, it was valid more as a personal and provisional insight than as a fact objectively derived from the presence of the pictures. It bothered me that they were so selfexplanatory, so easy to interpret; I found myself limited precisely by what ordinarily seemed to open up all sorts of vistas. I would have preferred them like that, without any statement, more discreet, more factual, left alone with themselves. I admired individual pieces in a new way, and rejected others which seemed to glisten in the reflections of their interpretation; until I reached

paintings are heavy. Landscapes, very light pencil outlines, and, here and there, as if just for emphasis and confirmation, there's an accidental scattering of color, a row of spots, wonderfully arranged and with a security of touch: as if mirroring a melody—."

works which I had not known. There were about fifteen new sheets which I found scattered among the others, all from the time when Rodin followed the dancing girls of King Sisowath² on their tour so as to be able to admire them longer and better. (Do you remember our reading about it?) There they were, these small graceful dancers, like transformed gazelles; the two long, slender arms drawn through the shoulders, through the slenderly massive torso (with the full slenderness of Buddha images) as if made of a single piece, long hammered out in the workshop, down to the wrists, upon which the hands then assumed their poses, agile and independent, like actors on the stage. And what hands: Buddha hands that know how to sleep, that lie down smoothly after all has passed, with fingers adjoining, to rest for centuries at the edge of a lap, lying with the palms facing up, or else steeply raised in the wrist, invoking infinite stillness. These hands in wakefulness: imagine. These fingers spread, open, starlike, or curved in upon each other as in a rose of Jericho; these fingers delighted and happy or else frightened, displayed at the very end of the long arms: themselves dancing. And the whole body

^{2.} In 1906, King Sisowath of Cambodia visited France.

is employed to keep this outermost dancing balanced in the air, in the body's atmosphere, in the gold of an Eastern aura. Once again he contrived almost cunningly to enlist every accident; a brown thin tracing paper which, when mounted, produces small manyfold creases reminiscent of Persian script. And the tint covering this with enamel-smooth rose, with a hermetic blue, as if from the most precious miniatures, and yet, as always in his pictures, quite primitive. One thinks of flowers; of pages in a herbarium, where the process of desiccation lends the most accidental gesture of a flower the ultimate precision of finality. Dried flowers. Naturally, soon after thinking this I read in his happy handwriting somewhere: "Fleurs Humaines": It's almost too bad that he doesn't leave it to us to think this far: since it's fairly apparent. And yet I was also moved that I had immediately understood him so literally, as often before. Good night. Until tomorrow . . .

Paris VIe, 29, rue Cassette, October 16, 1907 (Wednesday)

. . . but you must tell me first whether you're completely restored and rested? There was such great tiredness in your writing, and you also spoke of a cold. I hope that's no longer the case. The Tivoli¹ was obviously not right for you just then. Isn't that the most tortuous and unreal environment imaginable; no, it's beyond anything conceivable, that kind of variety show. You lose the ground beneath your feet, the air, the sky, everything real, and as if forever. I just felt the vaguely threatening memory of it (for evenings like this were imposed on me without mercy when I was a child) when I spent a half hour with von der Heydt² (back at the time when he was here) in one of those summer gardens by the Champs-Élysées. (And that was in the open air.) And in this unreality: animals: more real than anything. Human beings, how they play with

- 1. Outdoor variety show in Bremen.
- 2. Karl von der Heydt (1858–1922), banker and writer, a friend and sponsor of Rilke's since 1905. The first part of Rilke's *New Poems* is dedicated to him and his wife, Elisabeth.

everything. How blindly they misuse what has never been looked at, never experienced, distract themselves by displacing all that has been immeasurably gathered together. It is not possible that a time that can find satisfaction of its need for this kind of beauty should also admire Cézanne and understand something of his devotion and hidden glory. The merchants make noise, that is all; and those who have a need to attach themselves to these things could be counted on the fingers of two hands, and they stand apart and are silent.

You should only see the people going through the two rooms, say on a Sunday: amused, ironically irritated, annoyed, outraged. And when they finally arrive at some concluding remark, there they stand, these Monsieurs, in the middle of this world, affecting a note of pathetic despair, and you hear them saying: il n'y a absolument rien, rien, rien. And the women, how beautiful they appear to themselves, in passing; they recall with complete satisfaction that just a moment ago they saw their reflections in the glass doors as they stepped in, and now, with their mirror image in mind, they plant themselves for a moment, without looking, next to one of those touchingly tentative portraits of

Madame Cézanne,³ so as to exploit the hideousness of this painting for a comparison which they believe is so favorable to themselves. And someone told the old man in Aix that he was "famous." He, however, knew better within himself and let the speaker continue. But standing in front of his work, one comes back to the thought that every recognition (with very rare, unmistakable exceptions) should make one mistrustful of one's own work. Basically, if it is good, one can't live to see it recognized: otherwise it's just half good and not heedless enough...

^{3.} Cézanne painted twenty-six portraits of his wife. Two of them were shown at the memorial exhibition of 1907.

Paris VIe, 29, rue Cassette, October 17, 1907

... rain and rain, without stop yesterday, and just now it's beginning anew. Looking straight ahead, you'd think: it's going to snow. But last night I was awakened by the presence of moonlight in a corner above my rows of books; a spot that did not shine but covered a place on the wall like a patch of aluminum. And the room was full of cold night all the way into the corners; one could tell, lying in bed, that it was also under the wardrobe, under the chest of drawers and around the objects without any space in between, all around the brass chandeliers, which looked very cold. But the morning was bright. A broad east wind invading us with a developed front, because he finds the city so spacious. On the opposite side, westerly, blown, pushed out, cloud archipelagos, island groups, gray like the neck and chest feathers of aquatic birds in a too remotely blissful ocean of cold barely-blue. And underneath all this, low, there's still the Place de la Concorde and the trees of the Champs-Élysées, shady, a black simplified to green, beneath the western clouds. Toward the right there are

houses, bright, windblown, and sunny, and far off in the background in a blue dove-gray, houses again, drawn together in planes, a serried row of straight-edged quarrylike surfaces. And suddenly, as one approaches the obelisk (around whose granite there is always a glimmering of blond old warmth and in whose hieroglyphic hollows, especially in the repeatedly recurring owl, an ancient Egyptian shadow-blue is preserved, dried up as if in the wells of a paint box), the wonderful Avenue comes flowing toward you in a scarcely perceptible downward slope, fast and rich and like a river which with the force of its own violence, ages ago, drilled a passageway through the sheer cliff of the Arc de Triomphe back there by the Étoile. And all this lies out there with the generosity of a born landscape, and casts forth space. And from the roofs, there and there, the flags hold themselves ever more high up into the high air, stretching, flapping as if to take flight: there and there. That's what my walk to the Rodin drawings was like today. First Mr. Bernheim took me to his storage room and showed me: van Goghs. The night café¹ I already

1. Van Gogh painted his famous Night Café in September 1888. It was later acquired by the Museum of Modern Art in Moscow. After the revolution, it passed into the hands of American art collectors.

wrote about; but a lot more could be said about its artificial wakefulness in wine red, lamp yellow, deep and utterly shallow green, with three mirrors, each of which contains a different emptiness. A park or an alley in a town park in Arles,2 with black people on benches on the right and left, a blue newspaper reader in front and a violet woman in the back, beneath and among blows and slashes of tree- and bush-green. A man's portrait against a background (yellow and greenish yellow) that looks as if woven of fresh reed (but which, when you step back, is simplified to a uniform brightness): An elderly man with a short-cropped, black-and-white mustache, sparse hair of the same color, cheeks indented beneath a broad skull: the whole thing in blackand-white, rose, wet dark blue, and an opaque bluish white—except for the large brown eyes and finally: one of those landscapes he was always postponing and yet already painting again and again: a setting sun, yellow and orange red, surrounded by a shining of yellow, round fragments: against it, full of revolt, Blue, Blue, Blue the slope of curved hills, divorced from the

^{2.} This painting was also created in September 1888 in Arles. It is now in the Philips Memorial Gallery in Washington.

twilight by a strip of soothing pulsations (a river?), in which, transparent in darkly aged gold, in the slanted front third of the picture, you can make out a field and leaning groups of upright sheafs of corn.³ Then again the Rodins.

But now rain, rain: exhaustive and noisy, like in the country, without any other sounds in between. The round edge of the wall in the monastery garden is full of mosses and has spots of an utterly luminous green, such as I have never seen. Fare well for now . . .

^{3.} Landscape with Setting Sun was painted in St. Remy in 1889 and can now be seen in the Rijksmuseum Kröller-Müller in Otterloo (Holland).

Paris VIe, 29, rue Cassette, October 18, 1907 (Friday)

. . . You must have known while writing how good it would make me feel, that insight which inadvertently sprang from the comparison of the blue pages1 with what I've experienced in front of Cézanne. What you are now saying and affectionately confirming for me is something I had somehow suspected, although I would not have been able to say how far I had developed in the direction corresponding to the immense progress Cézanne achieved in his paintings. I was only convinced that there are personal inner reasons that make me see certain pictures which, a while ago, I might have passed by with momentary sympathy, but would not have revisited with increased excitement and expectation. It's not really painting I'm studying (for despite everything, I remain uncertain about pictures and am slow to learn how to distinguish what's good from what's less good, and am always confusing early and late works). It was the turning point in these paintings which I recognized, be-

1. Rilke wrote the New Poems on blue paper.

cause I had just reached it in my own work or had at least come close to it somehow, after having been ready, probably for a long time, for this one thing which so much depends on. That's why I must be careful in trying to write about Cézanne, which of course tempts me greatly now. It's a mistake (and I have to acknowledge this once and for all) to think that one who has such private access to pictures is for that reason justified in writing about them; their fairest judge would surely be the one who could quietly confirm them in their existence without experiencing in them anything more or different than facts. But within my life, this unexpected contact, the way it came and established itself, confirms a great many things and is most relevant. Another pauper. And what progress in poverty since Verlaine (if Verlaine wasn't already a relapse), who wrote under "Mon testament": Je ne donne rien aux pauvres parce que je suis un pauvre moi-même, and whose work is almost entirely marked by this not-giving, this embittered holding out of empty hands, something for which Cézanne, during his last thirty years, had no time. When could he have shown his hands? Not that they didn't attract malicious looks whenever he left the house, laid bare in their

poverty by an obscenely prying glance; but all we can learn of these hands from his work is how massively and how genuinely they labored unto the end. This labor which no longer knew any preferences or biases or fastidious predilections, whose minutest component had been tested on the scales of an infinitely responsive conscience, and which so incorruptibly reduced a reality to its color content that it resumed a new existence in a beyond of color, without any previous memories. It is this limitless objectivity, refusing any kind of meddling in an alien unity, that strikes people as so offensive and comical in Cézanne's portraits. They accept, without realizing it, that he represented apples, onions, and oranges purely by means of color (which they still regard as a subordinate means of painterly expression), but as soon as he turns to landscape they start missing the interpretation, the judgment, the superiority, and when it comes to portraits, there is that rumor concerning the artist's intellectual conception, which has been passed on even to the most bourgeois, so successfully that you can already see the signs of it in Sunday photographs of couples and families. And here Cézanne naturally strikes them as totally inadequate and not even worthy of discussion. He

is actually as alone in this Salon as he was in life, and even the painters, the young painters, walk by more quickly because they see the dealers on his side . . . A good Sunday to both of you . . .

Paris VIe, 29, rue Cassette, October 19, 1907

I'm sure you remember . . . in The Notebooks of Malte Laurids Brigge, the place that deals with Baudelaire and his poem: "Carrion." I was thinking that without this poem, the whole trend toward plainspoken fact which we now seem to recognize in Cézanne could not have started; first it had to be there in all its inexorability. First, artistic perception had to overcome itself to the point of realizing that even something horrible, something that seems no more than disgusting, is, and shares the truth of its being with everything else that exists. Just as the creative artist is not allowed to choose, neither is he permitted to turn his back on anything: a single refusal, and he is cast out of the state of grace and becomes sinful all the way through. Flaubert, in retelling the legend of Saint-Julien-l'hospitalier with such discretion and care, gave me this simple believability in the midst of the miraculous, because the

1. "La Charogne" ("Carrion") is one of the poems in Baudelaire's *Fleurs du Mal*. Rilke found the information about Cézanne and this poem in Bernard's article. See note on page 35.

artist in him participated in the saint's decisions, and gave them his happy consent and applause. This lying-down-with-the-leper and sharing all one's own warmth with him, including the heartwarmth of nights of love: this must at some time have been part of an artist's existence, as a selfovercoming on the way to his new bliss. You can imagine how affected I was when I read that even in his last years, Cézanne had memorized this entire poem-Baudelaire's Charogne-and recited it word for word. Surely one could find examples among his earlier works where he mightily surpassed himself to achieve the utmost capacity for love. Behind this devotion, in small ways at first, lies the beginning of holiness: the simple life of a love that endured; that, without ever boasting of it, approaches everything, unaccompanied, inconspicuous, wordless. One's real work, the abundance of tasks, begins, all of it, behind this enduring, and whoever has not been able to come this far may well meet the Virgin Mary in Heaven, and certain saints and minor prophets as well, and King Saul and Charles le Téméraire—: but as for Hokusai and Lionardo, Li Tai Pe and Villon, Verhaeren, Rodin, Cézanne—of these, not to mention the good Lord, all he will ever learn, even there, is hearsay.

And suddenly (and for the first time) I understand the fate of Malte Laurids. Isn't it this: that this testing by the real exceeded his capacities, that he failed, even though in his mind he was so convinced of the need for this testing that he instinctively sought it out until it embraced him and clung to him and never left him again? The book of Malte Laurids, once it is written, will be but the book of this realization, proven in the failure of one for whom it was too vast, too great. And perhaps he passed the test, after all: for he wrote the death of the chamberlain;2 but like Raskolnikov he was left behind, used up by his deed, ceasing to act at the moment that called for action to begin, so that his new, hard-gained freedom turned against him and, finding him defenseless, tore him to pieces.

Ah, we compute the years and divide them here and there and stop and begin and hesitate between both. But how of one piece is everything we encounter, how related one thing is to the next, how it gives birth to itself and grows up and is educated in its own nature, and all we basically have to do is to *be*, but simply, earnestly, the way the earth simply is, and gives her consent to the

^{2.} The Notebooks of Malte Laurids Brigge, Complete Works, Vol. 6, p. 722 ff.

seasons, bright and dark and whole in space, not asking to rest upon anything other than the net of influences and forces in which the stars feel secure.

Some day the time and composure and patience must also be there to let me continue writing the Notebooks of Malte Laurids; I now know much more about him, or rather: the knowledge will be there when it is needed . . .

Paris VIe, 29, rue Cassette, Sunday afternoon, October 20, 1907

. . . Yes, your letter was there on Sunday; when I came back from lunch, it received me. A welcome to your small-small studio; as for the large one, the truly large space, we carry it within ourselves. If that were something one could rent or buy! But this will never be within our means.

For quite some time, being outdoors had become unpleasant here on account of the wet and the cold; even so, there were some brave souls who still lingered in front of the door at Jouven's, since the tables were still out there; just for one really bad day the "terrasse" (as they call it) was removed; but today, once again, and quite unexpectedly, one was sitting in mellow quiet sunlight; the morning was radiant. But even as I write, the day is graying, with single bird cries as before a rain, and the steps in the alley below have become fewer. I took my Sunday walk to the Salon again; through the quiet Faubourg Saint-Germain, past the palaces, above whose high front gates the old, great names are sometimes still visible: Hotel de Castries, Hotel d'Aravay, and over one of them: Hotel Orloff,

belonging to the rich family who rose to superabundance and princely estate with the help of the great Catherine; it produced brilliant gentlemen and also beautiful women whose smiles endowed their lineage with a past, Princesses Orloff, admired by all of Paris. You know: there's the highly arched gateway in the front building, massive and heavy, windows on the right and left which are so uninterested in looking outside that they turn their backs on the street; only the doorkeeper's window is clear and attentive in front of its modestly parted curtains. But as soon as one of the weighty wings of the door opens, refulgent in its smooth dark green, the gaze can no longer be restrained. Beyond the semidarkness of the gateway, the palace steps back as if to show itself (the way someone might show off a new dress), far away from the street. Its middle door, which is all of glass, tosses a few stairs down toward the gravel of the untouched courtyard, and standing behind all the windows, which are scarcely smaller than the door, are curtains, as if in beautiful dresses. Where they are missing, you can see the band of the staircase being gently led up in tranquil ascent. And one can sense the coolness of a vestibule, with cold walls that are reserved and unparticipating, like servants at the

table, and whose only purpose is to pass the candlesticks around in the evening. One senses, too, and believes, that these palaces have royal rooms in the interior, there is something in one's blood that belongs in there, and for a second the whole gamut of emotions rests between the heaviness of bronze-encased ancient Chinese porcelain and the lightness of a chime's voice:—but one goes to the picture gallery, where none of this means anything, at least not the way it stands there in the rue Saint-Dominique, nor the way it can be in a little bit of blood that occasionally runs through one's heart with a scent like that of an old perfume. But all this will have to be shed, dismissed, put away. Even someone who had such palaces to utter would have to approach them innocently and in poverty, and not as someone who could still be seduced by them. Surely one has to take one's impartiality to the point where one rejects the interpretive bias even of vague emotional memories, prejudices, and predilections transmitted as part of one's heritage, taking instead whatever strength, admiration, or desire emerges with them, and applying it, nameless and new, to one's own tasks. One has to be poor unto the tenth generation. One even has to be poor for those who preceded one, otherwise one only reaches back to the time of their rise, of their first brilliance. But one has to feel beyond them into the roots and into the earth itself. One has to be able at every moment to place one's hand on the earth like the first human being.

... Fare well ... until tomorrow ...

Paris VIe, 29, rue Cassette, October 21, 1907

... There's something else I wanted to say about Cézanne: that no one before him ever demonstrated so clearly the extent to which painting is something that takes place among the colors, and how one has to leave them alone completely, so that they can settle the matter among themselves. Their intercourse: this is the whole of painting. Whoever meddles, arranges, injects his human deliberation, his wit, his advocacy, his intellectual agility in any way, is already disturbing and clouding their activity. Ideally a painter (and, generally, an artist) should not become conscious of his insights: without taking the detour through his reflective processes, and incomprehensibly to himself, all his progress should enter so swiftly into the work that he is unable to recognize them in the moment of transition. Alas, the artist who waits in ambush there, watching, detaining them, will find them transformed like the beautiful gold in the fairy tale which cannot remain gold because some small detail was not taken care of. That van Gogh's letters1 are so readable,

1. Rilke is referring to a selection of van Gogh's letters translated into German. He had read them on his trip from Munich to Naples (November 28, 1906).

that they are so rich, basically argues against him, just as it argues against a painter (holding up Cézanne for comparison) that he wanted or knew or experienced this and that; that blue called for orange and green for red: that, secretly listening in his eye's interior, he had heard such things spoken, the inquisitive one. And so he painted pictures on the strength of a single contradiction, thinking, at the same time, of the Japanese simplification of color, where separate planes are added or subtracted on a gradient of tones combining into a sum total; leading, again, to the drawn and explicit (i.e., invented) contour of the Japanese as a frame for the coordinate planes; leading, in other words, to a great deal of intentionality and arbitrariness-in short, to decoration. Cézanne, too, was provoked by the letters of a writing painter—who, accordingly, wasn't really a painter-to make some pronouncements about painting;2 but when you see the few letters the old man wrote: how awkward this effort at self-explication remains, and how extremely repugnant it was to him. He was almost incapable of saying anything. The sentences in which he attempted it become long and

2. Rilke knew only the Cézanne letters published by Bernard in his article.

convoluted, they balk and bristle, get knotted up, and finally he drops them, beside himself with rage. On the other hand, he manages to write very clearly: "I believe the best thing is work." Or: "I'm making progress every day, although very slowly." Or: "I am almost seventy years old." Or: "I will answer you through pictures." Or: "L'humble et colossal Pissarro---" (who taught him how to work), or: after some thrashing about (one senses with what relief, in beautiful script): the signature, unabbreviated: Pictor Paul Cézanne. And in the last letter (of September 21, 1905), after complaining about his bad health, simply: Je continue donc mes études. And the wish that was literally fulfilled: Je me suis juré de mourir en peignant. Just as in an old picture of the dance of death, that's the way death seized his hand from behind, painting the last stroke himself,3 quivering with pleasure; his shadow had been lying on the palette for a while, and he had had time to select from among the open round sequence of colors the particular one he liked most; as soon as that color would get into the brush, he would reach in and paint . . . there it

3. The painter was found unconscious on the road to Lauves, where a thunderstorm had surprised him "sur le motif." He died two days later (October 23, 1906).

was; he took the hand and made his stroke, the only one he was capable of.

Yesterday I saw Osthaus⁴ in the Salon (without his recognizing me); he seemed to be interested in buying a few things. And Dr. Elias,⁵ whom we met at Fischer's⁶ (who sends you his best regards); for the rest, he talked about and in front of Cézanne: "Double world." And I'm thinking of my trip and the people who will talk, in Prague, in Breslau, in Vienna,—and the misunderstandings. All talk is misunderstanding. Insight is only within the work. No doubt about it. It's raining, raining, . . . and tomorrow they're closing the Salon, which was practically my apartment in recent weeks. Fare well for today . . .

^{4.} Karl Ernst Osthaus (1874–1921), collector and writer on artistic subjects, founder of the Folkwang Museum in Hagen (Westphalia). He owned two landscapes by Cézanne.

^{5.} Dr. Julius Elias, a collector and writer from Berlin, translator of Ibsen. He, too, owned a Cézanne.

^{6.} Samuel Fischer (1859–1934), founder of the S. Fischer Verlag in Berlin.

Paris VIe, 29, rue Cassette, October 22, 1907

... the Salon is closing today. And already, as I'm leaving it, on the way home for the last time, I want to go back to look up a violet, a green, or certain blue tones which I believe I should have seen better, more unforgettably. Already, even after standing with such unrelenting attention in front of the great color scheme of the woman in the red armchair, it is becoming as unretrievable in my memory as a figure with very many digits. And yet I memorized it, number by number. In my feeling, the consciousness of their presence has become a heightening which I can feel even in my sleep; my blood describes it within me, but the naming of it passes by somewhere outside and is not called in. Did I write about it?—A red, upholstered low armchair has been placed in front of an earthy-green wall in which a cobaltblue pattern (a cross with the center left out $-\frac{1}{4}$) is very sparingly repeated; the round bulging

1. This portrait of Madame Cézanne, formerly in the Fabbrizi collection in Florence, is now in the Robert Treat Paine collection in Boston. The wall pattern appears in several other pictures.

back curves and slopes forward and down to the armrests (which are sewn up like the sleevestump of an armless man). The left armrest and the tassel that hangs from it full of vermilion no longer have the wall behind them but instead, near the lower edge, a broad stripe of greenish blue, against which they clash in loud contradiction. Seated in this red armchair, which is a personality in its own right, is a woman, her hands in the lap of a dress with broad vertical stripes that are very lightly indicated by small, loosely distributed flecks of green yellows and yellow greens, up to the edge of the blue-gray jacket, which is held together in front by a blue, greenly scintillating silk bow. In the brightness of the face, the proximity of all these colors has been exploited for a simple modeling of form and features: even the brown of the hair roundly pinned up above the temples and the smooth brown in the eyes has to express itself against its surroundings. It's as if every place were aware of all the other places—it participates that much; that much adjustment and rejection is happening in it; that's how each daub plays its part in maintaining equilibrium and in producing it: just as the whole picture finally keeps reality in equilibrium. For if one says, this is a red armchair

(and it is the first and ultimate red armchair ever painted): it's true only because it contains latently within itself an experienced sum of color which, whatever it may be, reinforces and confirms this red. To reach the peak of its expression, it is very strongly painted around the light human figure, so that a kind of waxy surface develops; and yet the color does not preponderate over the object, which seems so perfectly translated into its painterly equivalents that, while it is fully achieved and given as an object, its bourgeois reality is at the same time relinquishing all its heaviness to a final and definitive pictureexistence. Everything, as I already wrote, has become an affair that's settled among the colors themselves: a color will come into its own in response to another, or assert itself, or recollect itself. Just as in the mouth of a dog various secretions will gather in anticipation at the approach of various things-consenting ones for drawing out nutrients, and correcting ones to neutralize poisons: in the same way, various intensifications and dilutions take place in the core of every color, helping it to survive contact with others. In addition to this glandular activity within the intensity of colors, reflections (whose presence in nature always surprised me so: to discover the evening glow of the water as a permanent coloration in the rough green of the Nenuphar's covering-leaves—) play the greatest role: weaker local colors abandon themselves completely, contenting themselves with reflecting the dominant one. In this hither and back of mutual and manifold influence, the interior of the picture vibrates, rises and falls back into itself, and does not have a single unmoving part. Just this for today . . . You see how difficult it becomes when one tries to get very close to the facts . . .

Paris VIe, 29, rue Cassette, October 23, 1907

... I wondered last night whether my attempt to give you an impression of the woman in the red armchair was at all successful. I'm not sure that I even managed to describe the balance of its tonal values; words seemed more inadequate than ever, indeed inappropriate; and yet it should be possible to make compelling use of them, if one could only look at such a picture as if it were part of nature—in which case it ought to be possible to express its existence somehow. For a moment it seemed easier to talk about the self-portrait;1 apparently it's an earlier work, it doesn't reach all the way through the whole wide-open palette, it seems to keep to the middle range, between yellow-red, ocher, lacquer red, and violet purple; in the jacket and hair it goes all the way to the bottom of a moist-violet brown contending against a wall of gray and pale copper. But looking closer, you discover the inner presence of light greens and juicy blues chasing the reddish tones outward and defining the lighter areas

1. The self-portrait in the Pellerin collection in Paris, painted between 1873 and 1876.

more precisely. In this case, however, the object itself is more tangible, and the words, which feel so unhappy when made to denote purely painterly facts, are only too eager to return to themselves in the description of the man portrayed, for here's where their proper domain begins. His right profile is turned by a quarter in the direction of the viewer, looking. The dense dark hair is bunched together on the back of the head and lies above the ears, in such a way that the whole contour of the skull is exposed; it is drawn with eminent assurance, hard and yet round, the brow sloping down and of one piece, its firmness prevailing even where, dissolved into form and surface, it is merely the outermost contour containing a thousand others. The strong structure of this skull which seems hammered and sculpted from within is reinforced by the ridges of the eyebrows; but from there, pushed forward toward the bottom, shoed out, as it were, by the closely bearded chin, hangs the face, hangs as if every feature had been suspended individually, unbelievably intensified and yet reduced to utter primitivity, yielding that expression of uncontrolled amazement in which children and country people can lose themselves,—except that the gazeless stupor of their absorption has been replaced by an animal alertness which entertains an untiring, objective wakefulness in the unblinking eyes. How great this watching of his was and how unimpeachably accurate, is almost touchingly confirmed by the fact that, without even remotely interpreting his expression or presuming himself superior to it, he reproduced himself with so much humble objectivity, with the unquestioning, matter-of-fact interest of a dog who sees himself in a mirror and thinks: there's another dog.

Fare well . . . for now; perhaps you can see in all this a little of the old man, who deserves the epithet he applied to Pissarro: humble et colossal. Today is the anniversary of his death . . .

Paris VIe, 29, rue Cassette, October 24, 1907

... I said: gray—yesterday, when I described the background of the self-portrait, bright copper obliquely crisscrossed by a gray pattern;-I should have said: a particular kind of metallic white, aluminum or something similar, for gray, literally gray, cannot be found in Cézanne's pictures. To his immensely painterly eye it didn't hold up as a color: he went to the core of it and found that it was violet or blue or reddish or green. He particularly likes to recognize violet (a color which has never been opened up so exhaustively and so variously) where we only expect and would be contented with gray; but he doesn't relent and pulls out all the violet hues that had been tucked inside, as it were; the way certain evenings, autumn evenings especially, will come right up to the graying facades and address them as if they were violet, and receive every possible shade for an answer, from a light floating lilac to the heavy violet of Finnish granite. When I made this remark, that there is nothing actually gray in these pictures (in the landscapes, the presence of ocher and of unburnt

and burnt earth is too palpable for gray to develop), Miss Vollmoeller pointed out to me how, standing among them, one feels a soft and mild gray emanating from them as a kind of atmosphere, whereupon we agreed that the inner equilibrium of Cézanne's colors, which are never insistent or obtrusive, produces this calm, almost velvetlike air which is surely not easily introduced into the hollow inhospitality of the Grand Palais. Although one of his idiosyncrasies is to use pure chrome yellow and burning lacquer red in his lemons and apples, he knows how to contain their loudness within the picture: cast into a listening blue, as if into an ear, it receives a silent response from within, so that no one outside needs to think himself addressed or accosted. His still lifes are so wonderfully occupied with themselves. The frequently used white cloth, for one,1 which has a peculiar way of soaking up the predominant local color, and the things placed upon it now adding their statements and comments with all their heart, each in its own way. The use of white as a color was natural to him from the start: together with black, it defined the two limits of his wide-open palette, and in the very

^{1.} There were several such still lifes at the exhibition.

beautiful ensemble of a black stone mantelpiece with chimney-clock, black and white (the latter in a cloth that covers part of the mantel and hangs over its edge) behave perfectly colorlike next to the other colors, their equal in every way, as if long acclimatized. (Differently from Manet, whose black has the effect of a light being switched off and yet still stands opposed to the other colors as if coming from some other place.) Brightly confronting each other on the white cloth are a coffee cup with a heavy dark-blue stripe on the edge, a fresh, ripe lemon, a cut crystal chalice with a sharply scalloped edge, and, way over on the left, a large, baroque triton shell-eccentric and singular in appearance, with its smooth, red orifice facing the front. Its inward carmine bulging out into brightness provokes the wall behind it to a kind of thunderstorm blue, which is then repeated, more deeply and spaciously, by the adjoining gold-framed mantelpiece mirror; here, in the mirror image, it again meets with a contradiction: the milky rose of a glass vase which, standing on the black chimneyclock, asserts its contrast twice (first in reality, then, a little more yieldingly, in reflection). Space and mirror-space are definitively indicated and distinguished-musically, as it were-by this

double stroke; the picture contains them the way a basket contains fruits and leaves: as if all this were just as easy to grasp and to give. But there's still some other object on the bare mantelpiece, pushed up against the white cloth; I'd like to go back to the picture to see what it was.² But the Salon no longer exists; in a few days it will be replaced by an exhibition of automobiles which will stand there, long and dumb, each one with its own idée fixe of velocity. Fare well for today . . .

2. The still life with the black clock was considered the masterpiece of Cézanne's early years. It belonged to his friend Zola, was later acquired by the Pellerin collection, and is now in the private Niarchos collection in Paris.

Paris VIe, 29, rue Cassette, October 25, 1907

. . . Though there's time till Sunday and I can't imagine not writing my daily letter, I'm limiting myself to a postcard; I'm sure you know why. Now that Cézanne had externally run its course, I asked myself: what next? It had gotten too late for everything. I was obstinate enough to still think of Venice, even yesterday; (for it was calling, as it had been calling throughout the weeks). But could I justify it? And wouldn't I be rushing into something that should happen more calmly? I thought back and forth; repeatedly, on and off, there was the very great temptation to go to the two of you after all. Even if just for a moment. For I'd have to be in Prague by the first, if I didn't want to set off in a hurry. Finally I decided upon the most frugal solution: to stay here, till Wednesday or Thursday, and take the most direct route (via Nuremberg) to Prague. But today began with such painfully wet coldness and I was feeling so badly treated and uncared for everywhere (you know what it can be like here on heatless prewinter days) that I made up my mind to pack my things first of all (I haven't done any of that

yet), just so I'll be *able* to leave at any moment. I have to write three more letters concerning the lectures, then I'm packing, this evening and all day tomorrow...

Prague, Hotel Erzherzog Stefan, Wenzelsplatz [November 1, 1907]

. . . will one be here someday and also be able to see this, see it and say it, from presence to presence?1 Will one no longer have to carry its heaviness, the immense importance it assumed because one was little and it was already big and growing beyond one; at the time, it used one in order to feel itself. There was a child, and all of this experienced itself in him, saw itself fantastically and hugely reflected in him, and treated his heart with haughty and fateful defiance. Now it's no longer allowed to be that way. Degraded beneath itself, reverted like one who has long done violence, it is somehow ashamed before me, exposed, closed in, as if it were meeting with justice and retribution. But I cannot take pleasure in seeing ill treatment being given to that which once dealt with me harshly and high-handedly and never condescended to explain to me what a difference is set between

^{1.} Rilke had left Paris on October 31 to lecture in Prague and Breslau.

us, what a hostile kinship. It makes me sad to see these corners of buildings, these windows and gateways, squares and steeples humiliated, smaller than they were, reduced and completely in the wrong. And now, in their new condition, I find them as impossible to cope with as when they were vainglorious. And their heaviness has turned into its opposite, but it's still the same heaviness, place by place. Today more than ever I've been feeling the presence of this city as incomprehensibility and confusion. It would have to either have passed away with my childhood, or my childhood would have to have flowed away from it later, leaving it behind, real among all the rest of reality, something to see and objectively tell, like a thing in Cézanne, incomprehensible for all I care, but tangible. But this way it is ghostly, like the people of the past who belong both to me and to the city and who bring us together and name us together.—I have never felt this with such strangeness, my rejection was never so great as this time—(probably because by now my propensity to look at and take everything with a view to my work has developed more strongly).

So I've been in Prague since this morning

and am writing you this as my first greeting from the first destination of my trip...

Naturally everyone's asked about you and Ruth.² But you are as far away as I am, and somehow that moves us closer together and away from this self-willed old city.

Fare well for today ...

^{2.} Rilke's daughter.

November 4 [1907]. Morning. In the train Prague-Breslau

... will you believe that I came to Prague to look at Cézannes? ... Outside in the Manes-Pavilion, where the Rodin exhibit used to be, there was (as I fortunately learned just in time) an exhibition of modern pictures. The best and most remarkable: Monticelli and Monet well represented, Pissarro adequately; 3 things by Daumier. And 4 Cézannes. (Van Gogh too, Gauguin, Émile Bernard: each with several pieces.) But Cézanne: a large portrait, a seated man (M. Valabrègue) with lots of black on a lead-black ground. His

- 1. The exhibition of modern French painting in the Manes-Pavilion, the showplace of the young Czech artists, combined works of the preimpressionist (Monet and Pissarro) and postimpressionist generations.
- 2. Adolphe Monticelli (1824–1886). Claude Monet (1840–1926). Camille Pissarro (1830–1903). Honoré Daumier (1808–1879). Vincent van Gogh (1853–1890). Paul Gauguin (1848–1903). Émile Bernard (1868–1941).
- 3. Antony Valabrègue (1844–1900), art critic and writer, composed a large study of two painters, the brothers Le Nain. He was a childhood friend of Cézanne and a lifelong friend of Zola, who was the owner of the painting. It is now in the National Gallery in Washington, D.C.

face, and his fists resting on his lap below, their skin tones intensified all the way to orange, are strongly and unequivocally put there. A still life, equally preoccupied with black;4 on a smoothly black table a long loaf of white bread in natural yellow, a white cloth, a thick-walled wine glass on a stem, two eggs, two onions, a tin milk container, and, obliquely resting against the loaf, a black knife. And here, even more than in the portrait, black is treated purely as a color, not as its opposite, and is recognized again as a color among colors everywhere: in the cloth, over whose white it is spread, inside the glass, muting the white of the eggs and weighting the yellow of the onions to old gold. (Just as, without having quite seen this yellow yet, I surmised that there must have been black in it.) Next to this, a nature morte with a blue bed cover; between the cover's bourgeois cotton blue and the wall, which is suffused with a light cloudy bluishness, an exquisite, large, gray-glazed ginger pot holding its

^{4.} Still Life with White Bread: Cézanne's first still life (1865). Formerly in the H. Cassirer collection, now in the Cincinnati Art Museum.

^{5.} Still Life with Blue Blanket, painted ca. 1890/94. Formerly in Baron Hartvany's collection, Budapest. Now on loan to the Kunsthaus Zurich.

own between right and left. An earthy green bottle of yellow Curaçao and furthermore a clay vase with a green glaze reaching down two thirds of it from the top. On the other side, in the blue cover, some apples have partly rolled out from a porcelain dish whose white is determined by the blanket's blue. This rolling of red into blue is an action that seems to arise as naturally from the colorful events in the picture as the relationship between two Rodin nudes does from their sculptural affinity. And finally a landscape⁶ of airy blue, blue sea, red roofs, talking to each other in Green and very moved in this internal conversation, and full of understanding among one another...

That and the two hours on Janovitz castle⁷ were the best and most quiet of all. There would be a lot to tell about Janovitz too. Just the trip up there through the glazed hard fall afternoon and the naive land was so beautiful. I took the drive from the train and back to the train by myself. And that was Bohemia as I knew it, hilly

- 6. One of Cézanne's numerous depictions of the port of Marseille (Mer à l'Estaque).
- 7. Janovice, a castle near Prague belonging to the Baroness Sidonie Nádherný of Borutin (1885–1950).

like light music and suddenly flat again behind its apple trees, flat without much horizon and divided by ploughed fields and rows of trees like a folk song from refrain to refrain . . .

Other Fromm Paperbacks:

MOTHER AND DAUGHTER

The Letters of Eleanor and Anna Roosevelt edited by Bernard Asbell

FLAUBERT & TURGENEV

A Friendship in Letters edited and translated by Barbara Beaumont

SECRETS OF MARIE ANTOINETTE

A Collection of Letters edited by Olivier Bernier

KALLOCAIN

A Novel

by Karin Boye

TALLEYRAND

A Biography by Duff Cooper

VIRTUE UNDER FIRE

How World War II Changed Our Social and Sexual Attitudes by John Costello

PIAF

by Margaret Crosland

CHOURA

The Memoirs of Alexandra Danilova

BEFORE THE DELUGE

A Portrait of Berlin in the 1920's by Otto Friedrich

THE END OF THE WORLD

A History by Otto Friedrich

J. ROBERT OPPENHEIMER

Shatterer of Worlds by Peter Goodchild

THE ENTHUSIAST

A Life of Thornton Wilder by Gilbert A. Harrison

INDIAN SUMMER

A Novel

by William Dean Howells

A CRACK IN THE WALL

Growing Up Under Hitler by Horst Krüger

EDITH WHARTON

A Biography by R.W.B. Lewis

THE CONQUEST OF MOROCCO

by Douglas Porch

THE CONQUEST OF THE

SAHARA

by Douglas Porch

HENRY VIII

The Politics of Tyranny by Jasper Ridley

INTIMATE STRANGERS

The Culture of Celebrity by Richard Schickel

BONE GAMES

One Man's Search for the Ultimate Athletic High by Rob Schultheis

KENNETH CLARK

A Biography by Meryle Secrest

THE HERMIT OF PEKING

The Hidden Life of Sir Edmund

Backhouse

by Hugh Trevor-Roper

ALEXANDER OF RUSSIA

Napoleon's Conqueror by Henri Troyat